IMAGES
of America
OREGON ASYLUM

ON THE COVER: Evelene Calbreath, seen here at age 11 on a swing in front of the asylum, lived in the asylum with her father, Dr. John Calbreath; her mother, Irene; and her sister, Helen, age 21. Dr. Calbreath was superintendent from January 1, 1900, to December 31, 1907. (Courtesy of Oregon State Library.)

IMAGES of America
OREGON ASYLUM

Diane L. Goeres-Gardner

Copyright © 2013 by Diane L. Goeres-Gardner
ISBN 978-0-7385-9988-5

Published by Arcadia Publishing
Charleston, South Carolina

Printed in the United States of America

Library of Congress Control Number: 2012953407

For all general information, please contact Arcadia Publishing:
Telephone 843-853-2070
Fax 843-853-0044
E-mail sales@arcadiapublishing.com
For customer service and orders:
Toll-Free 1-888-313-2665

Visit us on the Internet at www.arcadiapublishing.com

This book is dedicated to all the employees who, over the last 130 years, worked to improve the lives of the Oregon State Hospital patients.

Diane L. Goeres-Gardner is an award-winning author of three previous history books: *Necktie Parties: Legal Executions in Oregon, 1851 to 1905*, published in 2005, and *Murder, Morality and Madness: Women Criminals in Early Oregon*, published in 2009, both by Caxton Press; and Images of America: *Roseburg*, published in 2010 by Arcadia Publishing. (Photograph by Laurie L. Burke.)

Contents

Acknowledgments		6
Introduction		7
1.	A New State Asylum	11
2.	The Calbreath Era	29
3.	The Golden Years	49
4.	Triumphs and Tragedies	81
5.	Tunnel Therapy	105
6.	Rebuilding the Hospital	121

ACKNOWLEDGMENTS

Special thanks to Laurie L. Burke, my daughter, for her photographs of the Oregon State Hospital tunnels and reconstruction efforts. Various libraries and archives were generous in their assistance and donations of photographs for this book. Photographs are courtesy of the following organizations:

NRHP	Photography by Tom Green, National Register of Historic Places nominated for the Oregon State Hospital Historic District, Oregon State Historic Preservation Office, 2008, Salem, Oregon.
ORE	*Oregonian* newspaper, Portland, Oregon.
OSA	Oregon State Archives, Salem, Oregon.
OSH	Oregon State Hospital, Salem, Oregon.
OSL	Oregon State Library, Salem, Oregon.
SJ	*Statesman Journal* newspaper, Salem, Oregon.
SPL	Salem Public Library Historic Photograph Collection, Salem Public Library, Salem, Oregon.
UofO	Historic American Buildings Survey in the University of Oregon Special Collections Library, Eugene, Oregon.
WHC	Willamette Heritage Center, Salem, Oregon.

Introduction

The story of Oregon State Hospital (OSH) is similar to that of other large mental hospitals built in the 1800s. It began with an idyllic dream that over the years gradually deteriorated into tragedy and despair. In the case of OSH, however, a series of incidents in 2008 provoked a reemergence of the dream, and today, a modern hospital has been built incorporating the old with the new.

Constructed in 1883, the main building followed the dictates of Thomas Kirkbride, the preeminent leader in asylum design during the 1800s. He advocated a building separating the sexes with a central tower for administration, employee housing, and public offices. The two wings made additions easy to build and allowed the patients room to socialize. At OSH another women's wing was added in 1888, and the men's wing in 1888, 1890, and 1926. This became the iconic J Building.

The campus occupies 130 acres within the city limits of Salem, the capital city of Oregon. Two other mental hospitals were eventually built, Eastern Oregon State Hospital in Pendleton in 1913 and Dammasch Hospital near Portland in 1961. Dammasch was closed in 1995. The name of the facility was changed from the Oregon State Insane Asylum to the Oregon State Hospital in 1913. That same year, the trustee system was dissolved and the Oregon State Board of Control was created to oversee the various public institutions in Oregon. It consisted of the governor, the secretary of state, and the state treasurer. OSH remains responsible for all the patients confined by the criminal justice system as "guilty except for insanity" and those needing to be evaluated to see if they can aid in their own defense.

OSH has always been supported by state taxes and ruled by the vagaries of state politics. For the most part, OSH superintendents were appointed and discharged at the whim of elected governors. Dr. R.E. Lee Steiner, serving from 1908 to 1937, was the longest-serving superintendent. Superintendents served as the public face of OSH and wielded almost unrestricted power over the patients and employees.

The years between 1883 and 1950 represented the biggest surge in building construction. A total of 31 major buildings and 28 cottages were added to the hospital. In 1955, the largest building, called the "50 Building" or Eola Hall, was constructed to hold the huge geriatric population. The last building project took place in 1958, when a second-story addition was added to Building 29, the administration building.

By 1960, the hospital had eight major buildings housing 53 wards with a licensed capacity of 2,974 beds. Additional structures included maintenance buildings; residences for physicians, nurses, and other personnel; and recreation facilities for personnel. Almost two miles of tunnels connected the various buildings and provided safe and secure transportation from place to place for patients and staff.

Treatment methods changed over time as hydrotherapy gave way to various kinds of shock therapy and lobotomies. In 1912, OSH built a new treatment hospital with the most up-to-date surgery center in the state. There, surgeons performed over 2,600 sterilizations based on the popular eugenics philosophy. Oregon performed the third-largest number of institutional sterilizations in the United States—mostly on persons termed sexually deviant, as defined at that time. OSH superintendents served on the Oregon Eugenics Board and were enthusiastic supporters of sterilization.

The hospital reached its peak population of 3,474 on June 30, 1958. That did not include 6,344 admissions during the previous two years, while 4,910 patients were paroled or discharged, 222 transferred, 428 escaped, and 721 died. Drug therapy, involving tranquilizers and phenothiazines, and community mental health facilities began reducing the number of patients confined at OSH. By 1962, there were 2,618 patients. Psychiatric treatment consisted of medication, electrotherapy, open wards, large and small group techniques, and practice in the skills of daily living through work, recreation, and creative arts. A unit of sexually dangerous individuals was added in 1963. Within five years, that unit had received over 70 cases. In 1965, the Psychiatric Security Unit was developed to deal with the increased forensic population. Four general groups of male patients were cared for in this new unit: mentally ill offenders transferred from the corrections facility; persons sent on court orders for psychiatric evaluation; those committed as sexually dangerous; and intra-hospital patients who required security measures. Maximum, medium, and minimum security was provided. An additional women's security unit was added two years later.

A "humanizing" program begun by Dr. Dean Brooks brought significant changes to the hospital. This was aimed at maintaining and reinforcing each patient's sense of worth and self-respect. This program included napkins at meals, drinking glasses on the wards, doors on the toilet stalls, and personal lockers for individual patients. He also developed and implemented a recreational camping program for patients into the Anthony Lakes Wilderness Area. As the patient numbers dropped and only the chronic cases remained, funding for the hospital also dropped. Buildings decayed, and wards were abandoned. He also supported the filming of *One Flew over the Cuckoo's Nest* inside OSH in 1972.

The Board of Control was dissolved in 1969, and the Department of Human Addiction and Mental Health was created to supervise OSH and other mental health facilities. In 1977, Oregon established the Psychiatric Security Review Board to oversee people ruled guilty of a crime "except for insanity" inside and outside the hospital. This revolutionary concept eventually spread to other states as forensic populations at other hospitals increased.

In 1990, OSH attempted to rename the buildings by replacing the building numbers with names. The J Building became Cascade Hall instead of Wards 30, 31, 41, 42, 43, 44, 45, 46, and 48. During the final decade of the 20th century, financial problems plagued the hospital, resulting in security, treatment, and building failures. Staff members were required to work increasing amounts of overtime, creating dangerous working conditions, employee fatigue, and plummeting morale.

By 2004, the hospital had become a facility housing a large forensic population and a much smaller number of other patients. On January 9, 2005, the Portland *Oregonian* began publishing a series of 15 editorials focusing on the hospital's decrepit condition. In proposing solutions, the editors recognized the complexity of the issues facing the mental health system and the difficulty involved in solving them. The hospital had closed many parts of the original building, and the surviving wards were very overcrowded. The newspaper won the 2006 Pulitzer Prize for editorial writing.

The Oregon Legislature authorized money in 2004 to study the future of OSH. The OSH Site Selection Committee picked the Salem site for a 620-bed facility and picked Junction City for a 360-bed facility. The entire Salem campus was listed in the National Register of Historic Places on January 15, 2008. New construction began on September 1, 2008, incorporating the oldest portion of the J Building into the new hospital. The final section opened in 2012. It contains 620 beds divided into four units: Harbors—a facility for maximum security; Trails—a facility for medium security; Bridges—a facility for minimum security and transition to community care;

and Springs—a facility for geriatric services. Renamed the Kirkbride U in honor of designer Thomas Kirkbride, the remodeled section now houses the Museum of Mental Health, displaying hospital artifacts, honoring the past employees and patients, and giving voice to the powerful stories narrating its turbulent history.

Today, the campus presents an open and parklike atmosphere with sweeping lawns, many mature evergreen and deciduous trees, and ornamental shrubs. The many curved avenues first developed in the 1880s still provide access to anyone visiting the hospital.

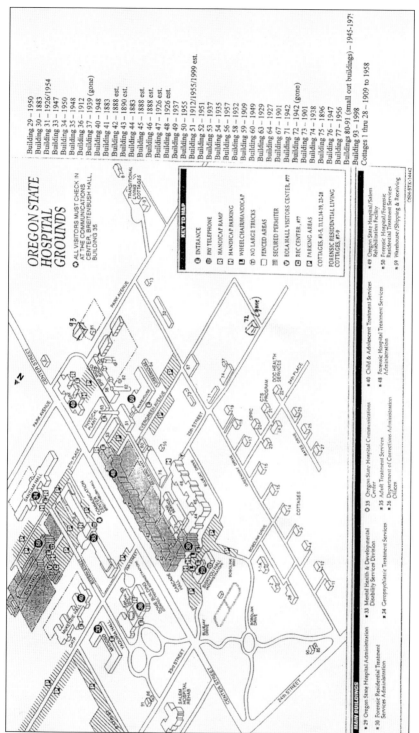

This map represents the Oregon State Hospital campus as it appeared in 1998, before the reconstruction program began. At top are the dates each building was constructed. This is one of the few maps that had both the building numbers and names identified. (Courtesy of OSH.)

One

A NEW STATE ASYLUM

As the Oregon authorities contemplated building Oregon's first mental asylum, its architects turned to Thomas Story Kirkbride, the famous supervisor of the Pennsylvania Hospital for the Insane and author of *On the Construction, Organization and General Arrangements of Hospitals for the Insane*. He advocated a center building for administration and housing for the resident physicians and their families with wings on each side for the patients. Named the Oregon State Insane Asylum (OSIA), the original three-story facility had medical facilities, a central kitchen and dining area, public visiting rooms, and a hall for lectures and worship services. Treatment focused on patients living in a quiet, wholesome atmosphere with good food, kindness, outside recreation, and country air.

On October 23, 1883, there were 268 men transported from the Hawthorne Asylum in East Portland to the new asylum in Salem. The next day, 102 women were also transferred. By 1900, the Oregon State Insane Asylum had added two wards on the women's side and four wards on the men's side and admitted a total of 5,046 since it had opened. Of those, 1,243 had been released as recovered, 1,051 as improved, and 405 as unimproved. At least 1,058 had died inside the asylum. During the first 17 years, five superintendents served at OSIA.

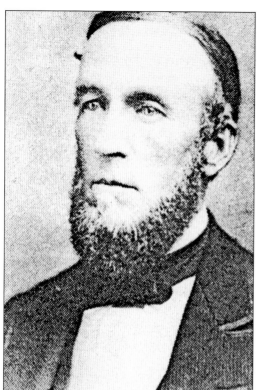

Dr. J.C. Hawthorne opened the private Oregon Insane and Idiotic Asylum (later referred to as the Hawthorne Asylum) in East Portland on September 2, 1861, under contract to care for Oregon's mentally ill patients. He based his treatment philosophy on "moral therapy." Patients were encouraged to enjoy outdoor activities and pleasant mental pursuits. Dr. Hawthorne died on February 16, 1881. (Courtesy of OSH.)

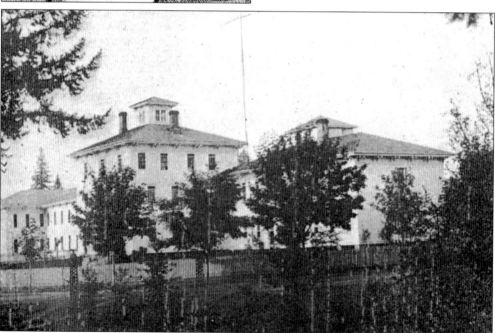

The two-story Hawthorne Asylum occupied 75 acres between what are now Northeast Ninth and Twelfth Avenues and Hawthorne Avenue and Belmont Street. There were three large wards for the harmless first-class patients and single rooms for the more violent. Also included were a chapel, a reading room, and a billiard room. (Courtesy of OSA.)

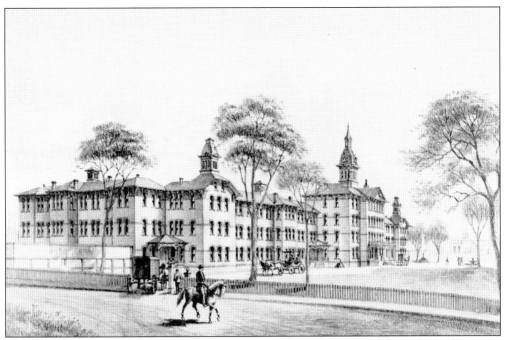

By July 1877, the Hawthorne Asylum had 230 patients and was costing the state about $70,000 a year, paid in gold, to support the asylum. The sum represented 42 percent of Oregon's annual tax base. It was costing $8,325 per year just in sheriff's bills for transporting patients to the asylum. (Courtesy of WHC, No. 2007.001.0302.)

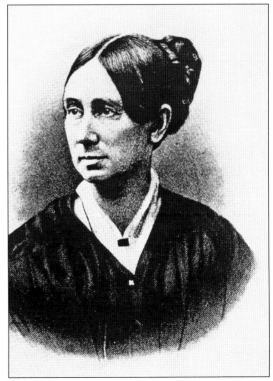

Various visitors wrote positive reports about their observations at the asylum, and officials appointed by the legislature praised the treatment and care of the patients. Dorothea Dix (1802–1887), a famous advocate for humanely operated insane asylums, visited the asylum twice and recommended that Dr. Hawthorne continue to care for the insane, as she believed the state was not prepared to care for them as well as the Hawthorne Asylum could. (Courtesy of OSH.)

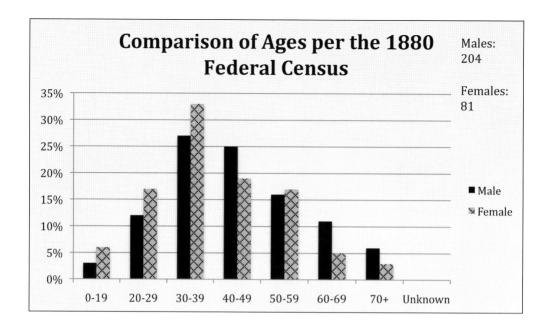

Cornelius Austin conducted the 1880 Federal Census in East Portland, Multnomah County, on June 16, 1880. Included was a list of the Hawthorne Asylum inmates. At that time, there were 285 inmates: 204 men and 81 women. Minorities included 20 Chinese men, one Chinese woman named Toy May, and one black man. The youngest was a girl aged nine, and the oldest was an 87-year-old woman. Analysis of the 1880 census shows that 50 percent of the women were married, versus 12 percent of the men. Nearly 65 percent of the men and only 35 percent of the women were single. None were listed as divorced. (Both, analysis by the author.)

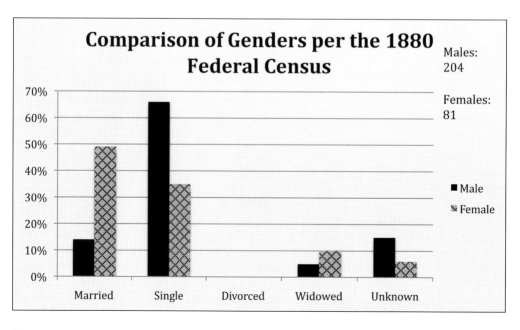

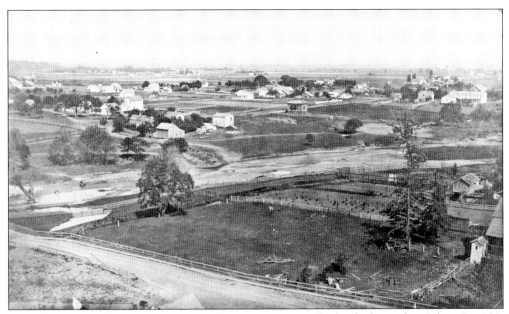

According to the Oregon constitution, all state institutions had to be located in Salem. In 1880, finally recognizing that they had three years until Hawthorne's contract expired, the legislature authorized the building of a state asylum in Salem. The site chosen was located on 107 acres about a half-mile east of the penitentiary. It sat on a small rise with a splendid view of the city. (Courtesy of SPL.)

Dr. Horace Carpenter was appointed superintendent of OSIA in 1882 to supervise its construction at a salary of $800 per year. He resigned on April 30, 1886, due to the fact that his nervous system demanded rest and OSIA was not the place to get it. Patients were being tricked to get them into the asylum. Some patients arrived strapped to the top of stagecoaches. (Courtesy of OSH.)

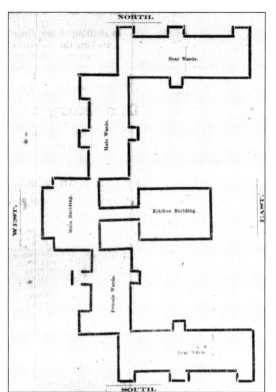

In 1880, the legislature finally allocated $184,000 to build the hospital. Thomas Kirkbride, of Pennsylvania, had just published his famous treatise on asylum design and management, *On the Construction, Organization, and General Arrangements of Hospitals for the Insane with Some Remarks on Insanity and Its Treatment*, and it had a major influence on Oregon's asylum project. He believed that architecture and landscape design had significant influence on a patient's mental condition. It all blended together in a patriarchal power structure intended to give patients a sense of stability and security. (Courtesy of OSA.)

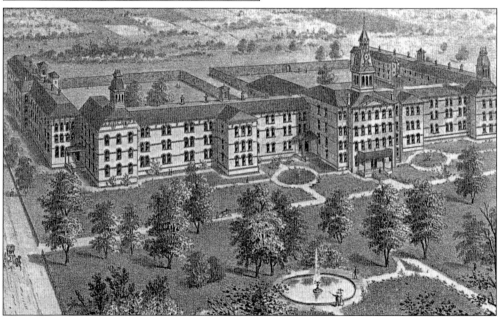

W.F. Boothby was the supervising architect and superintendent of construction. The new building was modified Italianate with a brick exterior, a gracious entrance, long hallways, and corridors extending from a central entrance. The entrance faced west and was 66 feet long and four stories high. It housed the superintendent and was used for administrative purposes. (Courtesy of OSA.)

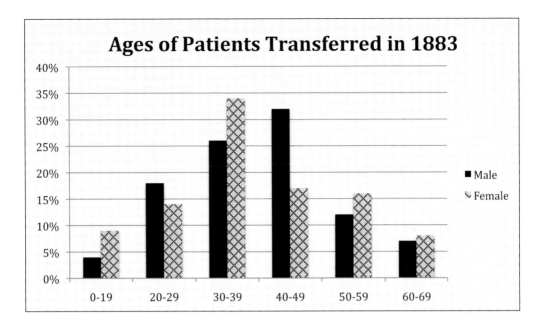

On October 23, 1883, at 10:00 a.m., a train from Portland to Salem transported 268 men, 15 of them from Idaho. The next day, 102 women were transferred the same way, for a total of 370 patients. Their ages ranged from seven to 83. The patients were primarily from Multnomah County. Only about 25 percent came from counties east of the mountains. Most of the men listed their occupation as laborer or farmer. The women were primarily housewives or domestic servants. Patient records included nativity, vocation, marriage status, date admitted, age, and county of origin. Nearly 50 percent of the patients had the cause of their insanity listed as unknown. Other causes were heredity, emotional issues, disease, injury, sexual problems (including menopause), overwork, alcohol, and old age. (Both, analysis by the author.)

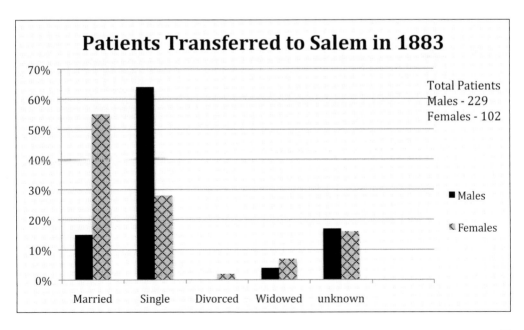

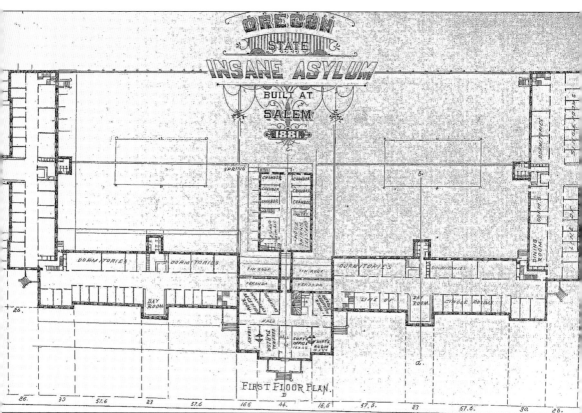

The first floor housed the 10-foot entrance hall, with the superintendent's public and private office to the right and the general reception room and library to the left. The hall intersected with the eight-foot-wide north/south hall, running into the female wards on the south and the male wards on the north, and continued east into the kitchen and dining room. The 12 wards were essentially identical, with 12-foot-wide corridors running 168 feet in length. Each ward had its own dining room, connected by dumbwaiter to the tunnels below, a bathroom, a water closet, a clothes room, and separate rooms for the patients. Two three-story wings ran east and west for 170 feet from the center section. A large auditorium/chapel occupied the second story. (Courtesy of OSA.)

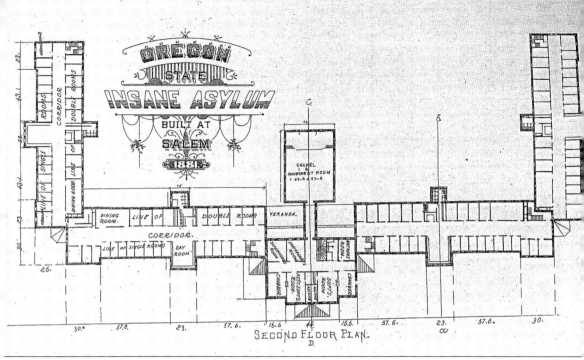

The center section was four stories tall, with a decorative cupola reaching 120 feet farther. Iron cresting and small cupolas topped the wings. The superintendent's living quarters were on the second floor, which included accommodations for assistants, supervisors, and matrons. The third floor contained living areas for attendants and other workers. The fourth floor was divided into seven large storage rooms. Verandas on the back of the office connected to the wards and were enclosed with wire mesh for the safety of the patients. The chapel was above the kitchen and dining room and had a stage with removable chairs. At that time, there was little access to outdoor activities. The tunnel system in the basement provided easy access to food and supplies. (Courtesy of OSA.)

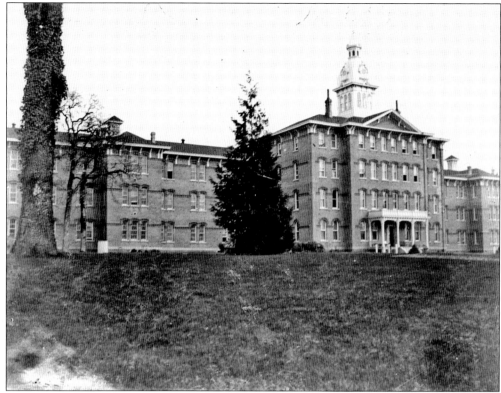

The finished building was impressive, with red brick, white woodwork, and a white cupola. By the end of 1884, there were 396 men and 145 women inmates. Bedtime was at 6:00 p.m., and gaslights were only lit for one hour a day. It was then costing the state $3 a week per patient, and the asylum gardens were providing a major portion of the food needed to feed the patients. This is the oldest known photograph of OSIA. (Courtesy of OSL.)

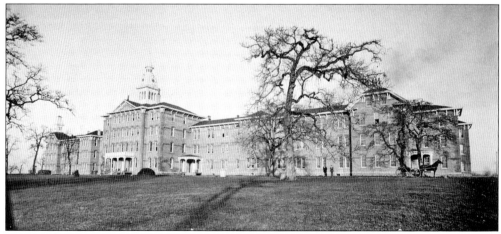

By 1891, there were 478 men and 212 women patients. While Dr. Harry Lane was superintendent, several outbuildings were erected, and two additional wings were added to the main asylum building, increasing capacity to 628 patients. Inside the main building, he replaced the gas lighting with electric lights. Hot-air furnaces were replaced with a hot-water heating system. (Courtesy of OSA.)

Dr. Simeon Josephi was superintendent of the Salem asylum for 14 months, from May 1, 1886, through July 1, 1887. He continued Dr. Hawthorne's modern methods of treating patients as individuals. (Courtesy of OSH.)

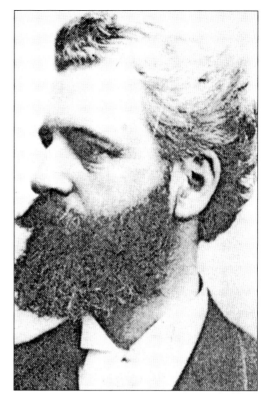

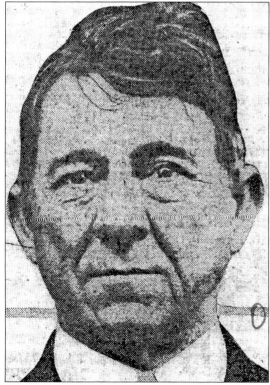

Dr. Harry Lane became superintendent on July 1, 1887, with 318 men and 148 women patients. He was responsible for implementing an aggressive vaccination program against smallpox. Due to political shenanigans, he was replaced on July 8, 1891. OSIA added a wing of three wards in 1886 on the south side and a wing on the north side in 1888. (Courtesy of OSH.)

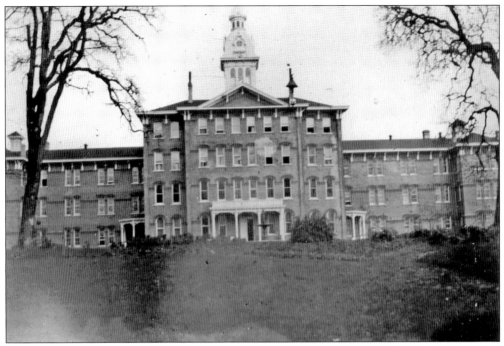

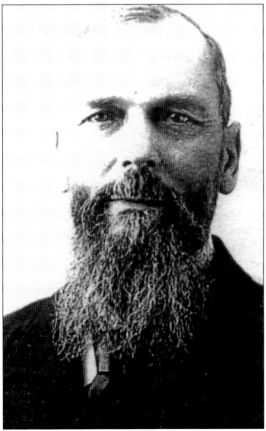

A report at the end of 1892 issued by the Oregon State Board of Corrections and Charities listed the following costs for the previous two years: $209,889 for maintenance, including $91,092 for payroll. The cost per inmate was $2.81 per week, for a daily average population of 767 inmates. In addition, it was costing $12,000 per biennium to transport patients from their homes to the asylum. (Courtesy of OSL.)

Dr. Levi L. Rowland was appointed superintendent on July 8, 1891, when OSIA had 713 patients. In 1892, the asylum opened its first infirmary and began requiring regular fire drills. Balls, dances, and parties became monthly activities for the next 20 years and were reported on a regular basis in the Salem newspapers. Dr. Rowland resigned on August 1, 1895. (Courtesy of OSA.)

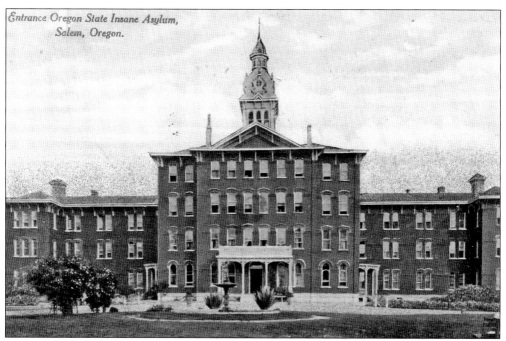

This postcard dates back to about 1900, before the Oregon Insane Asylum had been painted white in 1910 and renamed Oregon State Hospital in 1913. (Courtesy of OSH.)

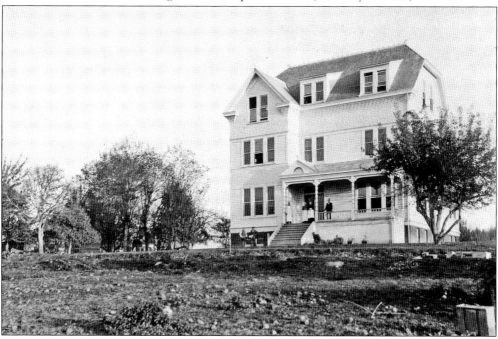

In 1889, the legislature appropriated $30,000 for the purchase of 640 acres about 3.5 miles from the asylum. An additional $24,000 was used to build two large barns and one large three-story building, containing a basement, parlors, a dining room, a kitchen, rooms for employees, dormitories for patients, and bathrooms. It was named the Cottage Farm in honor of Dr. Lane's vision. (Courtesy of OSA.)

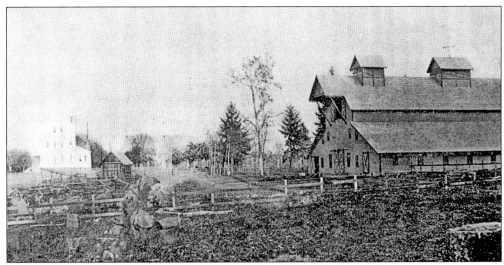

By 1903, approximately 270 patients lived and worked at the Cottage Farm. Two additional cottages, housing 80 patients each, were built the year before. A new dairy barn, a horse barn, and a building for raising pigs were also erected. A septic tank sewer system was constructed to replace the open ditch used previously. (Courtesy of OSA.)

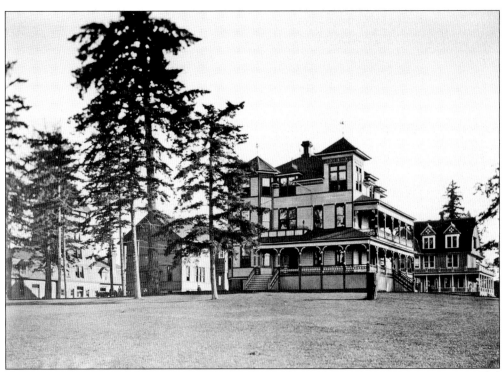

The farm was considered a more appropriate atmosphere for recovering patients, as it provided opportunities with "isolation, quiet, diversion, and a variety of objects to engage mental interest," according to the 1892 Board of Charities and Corrections report. It provided a better reproduction of family life than the asylum to prepare patients for returning home. (Courtesy of OSA.)

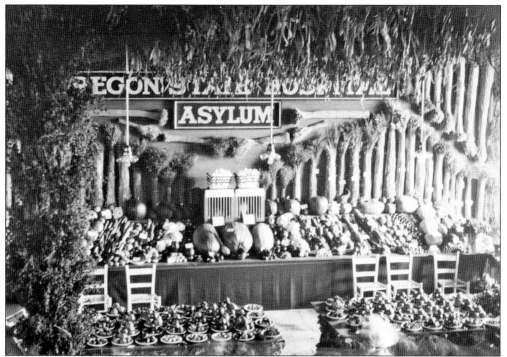

In 1892, this exhibit at the Oregon State Fair highlighted the produce grown on the Cottage Farm. The farm and dairy decreased the expense at OSIA and supplied better milk, fresher vegetables, and finer fruit than could be purchased. The farm also provided an inestimable benefit to hundreds of patients by offering healthful, productive labor. (Courtesy of SPL.)

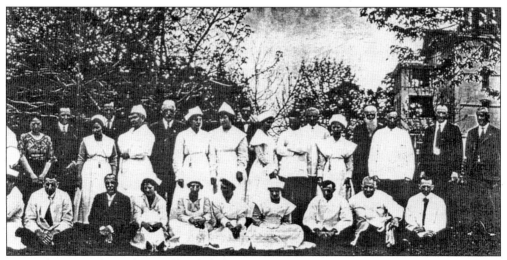

In October 1899, the asylum staff included 160 employees, many variously identified as members of the local political party. In addition to the physicians, there was a steward, a supervisor, and a person in charge of the kitchen. W.H. Cook and his wife, M.R., were in charge of the Cottage Farm. Oregon law recommended one attendant for every 19 patients. (Courtesy of OSH.)

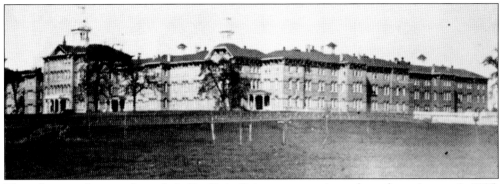

This photograph was taken while Dr. D.A. Paine was superintendent, from August 2, 1895, until January 1, 1900. The 1895 Oregon census showed 710 men and 290 women patients in the asylum. Of those, 23 were Chinese. Abuses during his term centered on patient care and the mismanagement of patients' funds and belongings. He was well known for using political affiliations and relationships to hire employees. (Courtesy of SPL.)

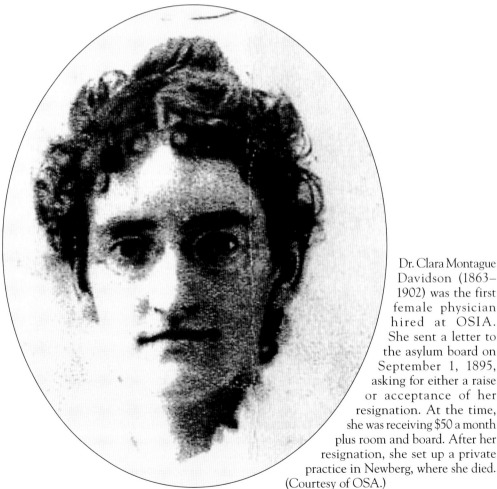

Dr. Clara Montague Davidson (1863–1902) was the first female physician hired at OSIA. She sent a letter to the asylum board on September 1, 1895, asking for either a raise or acceptance of her resignation. At the time, she was receiving $50 a month plus room and board. After her resignation, she set up a private practice in Newberg, where she died. (Courtesy of OSA.)

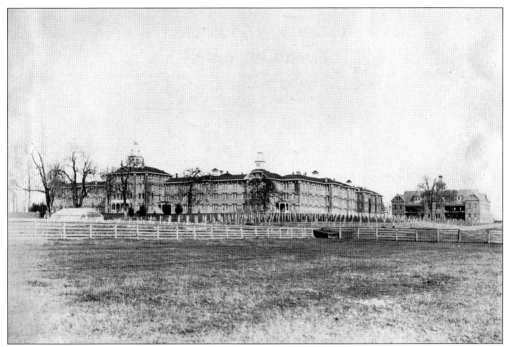

This photograph shows the south side or female wing of the J Building in 1888, after Building 46 and the infirmary were built. Malinda Applegate was a patient in the Hawthorne Asylum from May 18, 1878, until she died in OSIA on January 31, 1930. During the last few months of 1897, Applegate and three of her children were in the asylum at the same time. (Courtesy of OSL.)

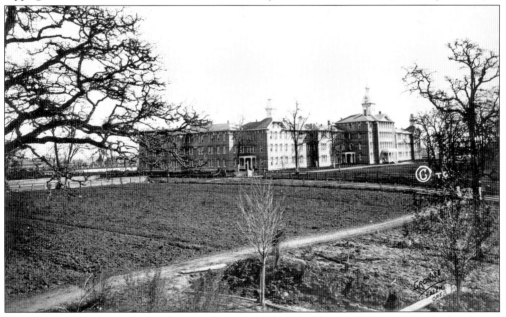

This photograph shows the north, or male, wing of the J Building in 1885. In 1889, the legislature appropriated $68,300 to add three wards, in Building 47, to the north wing of the main building. This brought the total number of beds available up to 630. By 1892, the institution consisted of the infirmary, the laundry, an engine room, a reservoir, a horse shed, and barns. (Courtesy of SPL.)

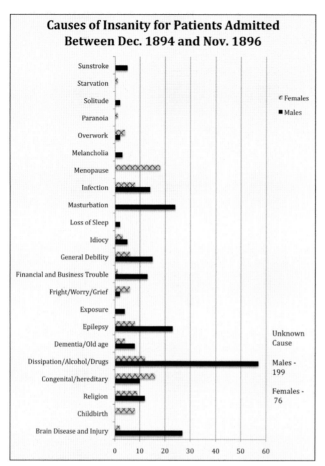

There was little known about the causes of insanity in the 1800s. This graph shows the causes as identified in the 1896 Biennial Report for the patients admitted between December 1894 and November 1896. For men, the most common cause listed was alcohol and drugs. For women, the most common cause was menopause. (Analysis by the author.)

In 1888, a new road (below) was built from downtown Salem to the asylum. It was originally called Asylum Avenue and extended from Fourteenth Street west to the city limits, three blocks north of State Street. When the city limits expanded east, Center Street assimilated Asylum Avenue. The streetcar line was extended to the asylum, and the first streetcar started running in July 1895. (Courtesy of OSH.)

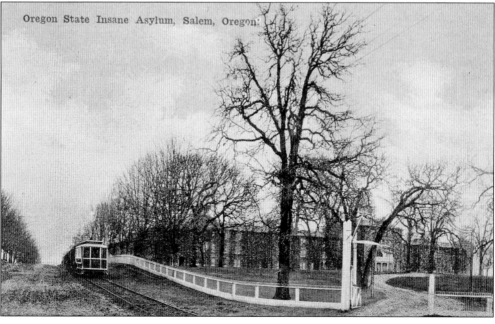

Two

THE CALBREATH ERA

At the beginning of the 1900s, the philosophy of an asylum changed from being a place where the insane had their bodily needs provided for but were prevented from becoming a danger to the community to being a hospital equipped and managed to provide an opportunity for patients to be restored to reason and return home. By 1900, the asylum was a self-sufficient community and had employees and patients supplying most of its needs.

The staff included Supt. John Calbreath, first assistant physician Dr. Walter Williamson, second assistant physician Dr. Lafayette Griffith, a druggist, a bookkeeper, a stenographer, a department overseer, an engineer, a supervisor, a matron, a basement man, a baker, cooks, a farmer, a dairyman, a night watchman, a watchwoman, an elevator operator, table girls, 40 female attendants, and 78 male attendants. The Calbreath family opened up the asylum to the surrounding community, and it soon became the social center of Salem society. Between 1906 and 1908, there were 986 people admitted for treatment; of those, 17 were under the age of 15. Most of the admissions were between the ages of 25 and 55. During that same two years, almost 300 people had died and 50 had escaped. By the time Dr. Calbreath left OSIA on December 31, 1907, there were 1,078 men and 480 women, for a total of 1,558 patients living in the asylum.

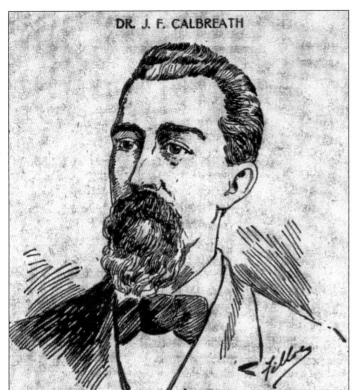

On January 1, 1900, Dr. John Calbreath, age 45, his wife, Irene, age 50, their daughter Helen, age 21, and their daughter Evelene, age 11, moved into the asylum. The family lived in seven rooms on the second floor. They had a dining room on the first floor and a kitchen in the basement. Dr. Calbreath was superintendent until December 31, 1907. (Courtesy of OSH.)

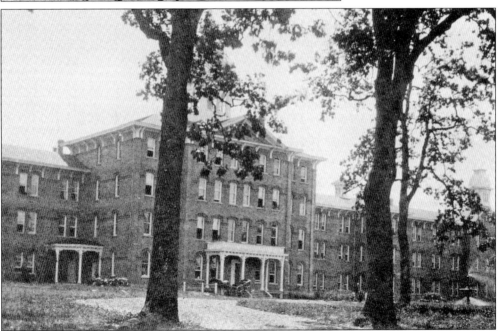

At the end of eight years, Dr. Calbreath had painted the inside and outside of the asylum, installed 600 new radiators, cleaned out the yards, cut out the trees, perfected the drainage, installed new showers and tubs, built fire escapes, and added a sprinkler fire system. He had also supervised the building of a new wing for female patients, costing $225,000. (Courtesy of OSH.)

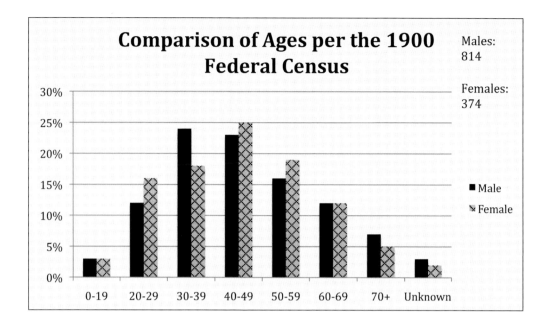

The 1900 Federal Census was conducted by Richard B. Goodin on June 30, 1900. The patients were listed alphabetically by gender. There were a total of 1,188 patients. Minorities included 24 Chinese men, two Chinese women, three black men, one black woman, one Indian man, one Indian woman, and one Japanese man. The youngest was eight, and the oldest was 86. Almost half of the women and 26 percent of the men were married. Only two women and three men were divorced. The most common causes of insanity in 1900 were excessive living, liquor, narcotics, and venereal disease. There were more than twice as many men as women patients, and many of the women were infected with syphilis. (Both, analysis by the author.)

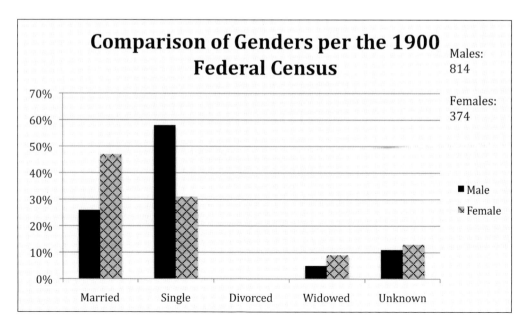

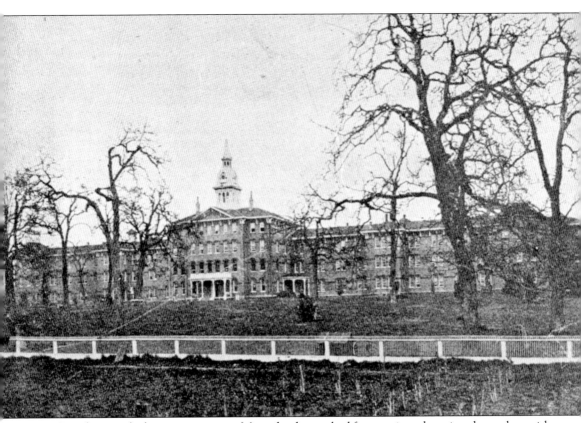

Suicides were fairly common events. Many deaths resulted from patients hanging themselves with clothing or bedding. On July 11, 1903, Mrs. J.G. Toile, age 31, managed to steal some matches and set herself on fire while hiding in the ward linen room. In addition to staff and patient housing, the 1903 J Building housed medical offices, intake rooms, visiting parlors, general offices, the main kitchen, a chapel (also used as a lecture hall), and storage for food, supplies, and patient belongings. (Courtesy of OSH.)

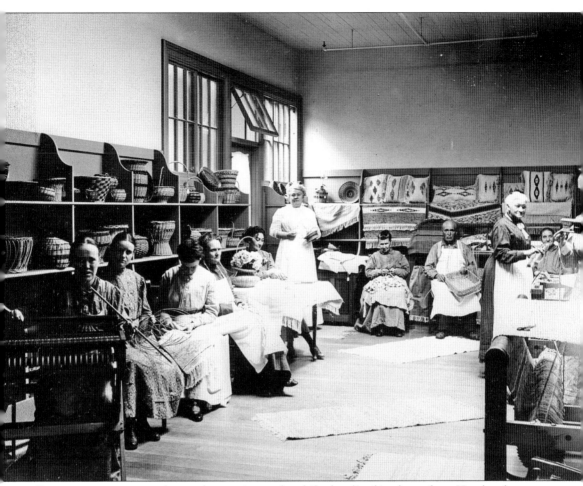

Patients were encouraged to work at various tasks while they lived in the asylum. Handwork was the main work of female patients as late as 1936. They also made baskets to use in the asylum. The shoe-making department manufactured leather cuffs, canvas mittens, leather mittens, leather muffs, foot restraints, and restraint straps. Muffs were pillow-like objects designed to keep a patient's hands enclosed so they could not hurt themselves or anyone else. (Courtesy of OSA.)

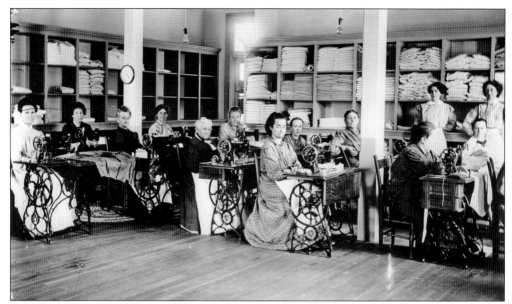

Women sewed linens and clothing for other inmates, and baskets were made to use throughout the asylum. Women also manufactured straightjackets, restraint sheets, and restraint waists—blouses for women that had long sleeves to keep their arms close to their bodies, similar to straightjackets for men. They also made silence cloths designed to tie around a patient's mouth to keep him or her quiet. (Courtesy of OSA.)

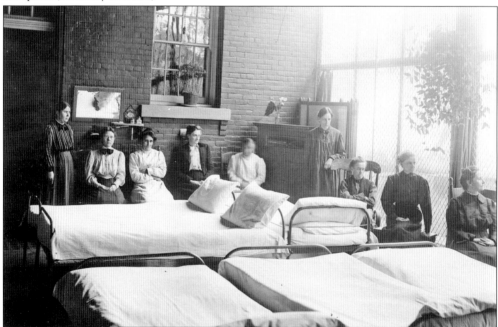

In 1904, Dr. Calbreath recommended that the state build special rooms for 63 patients infected with tuberculosis, not only to improve their chances of recovery but also to prevent contamination. The number of infected patients confined to the asylum had reached an all-time high, which made caring for them inside the asylum dangerous to other patients. Open-air sleeping porches were constructed to help alleviate the possibility of infection. (Courtesy of OSA.)

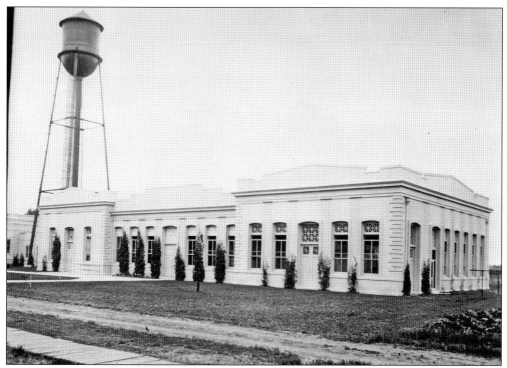

This water tower, built in 1891, was 85 feet high, with a galvanized iron tank 12 feet high and 30 feet in diameter. This tank held enough water to do laundry or to fight fires. The asylum supervisor and night watchman recorded the pressure hourly. The tank building also housed a blacksmith shop, a carpenter shop, a broom factory, and a shoe shop. (Courtesy of OSA.)

Various outbuildings were to the east of the J Building, including the tank tower, the laundry, a machine shop, a carpenter shop, horse sheds, and the reservoir. The reservoir was 40 feet by 80 feet and 14 feet deep. It provided water in case of a fire and served as a swimming pool the rest of the time. (Courtesy of OSA.)

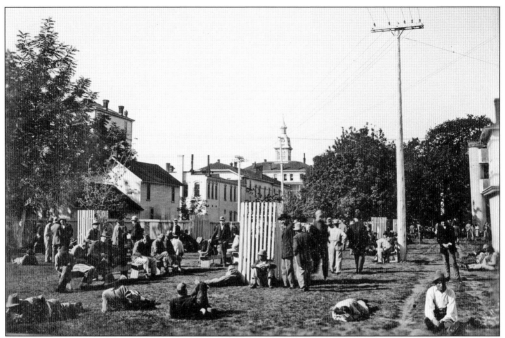

By 1900, it was evident that there was too little outdoor recreation available for many of the patients. The grounds were limited, and in their daily outings, the patients were restricted to a small area in back of the J Building. Men were also employed in an auto shop, a mattress factory, a tin shop, a cannery, and a carpenter shop. (Courtesy of OSA.)

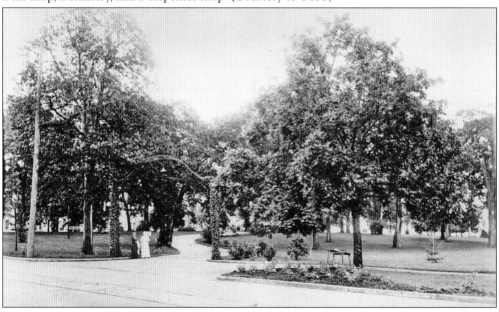

In 1913, the Eastern Oregon State Hospital opened, and 325 patients were transferred from OSIA. That same year, the asylum officially changed its name from the Oregon State Insane Asylum to the Oregon State Hospital. Other changes included removing the fence around the hospital and adding decorative bushes, trees, and flowers. This was one of the entrances off of Asylum Avenue. (Courtesy of OSA.)

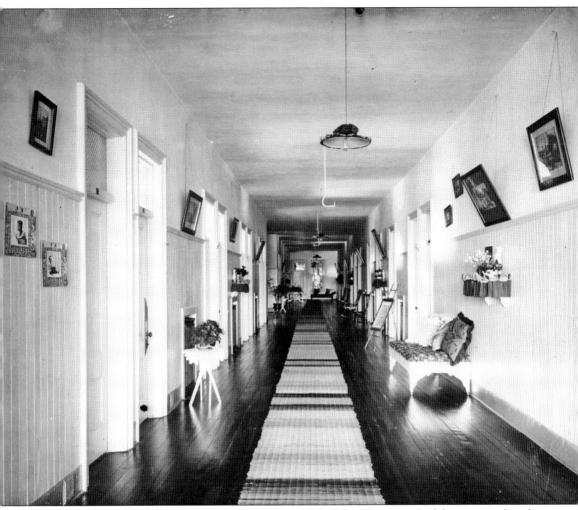

This was a typical hallway in the women's wards in 1900. When Rosanna Carlyle was transferred from the prison to OSIA on April 7, 1900, this is where she was assigned. Her belongings included a green straw hat, a black fur cape, a gray flannel petticoat, four flannel wrappers, two under vests, two pairs of drawers, a pair of shoes, three pairs of stockings, a pair of garters, a chemise, a calico dress, a union suit, a black dress, and twelve handkerchiefs. She was diagnosed with acute mania and returned to the penitentiary a year and nine months later, on December 30, 1901. She was released from prison nearly five years later, on September 11, 1906. (Courtesy of OSA.)

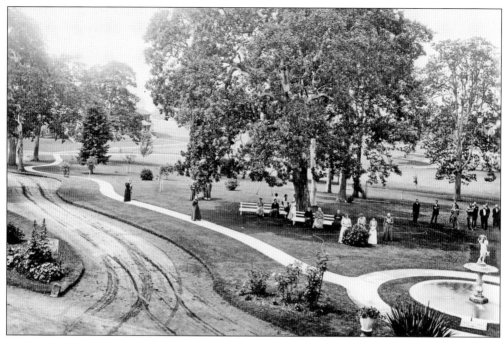

A local community group donated the "Little Hercules" fountain to the asylum in 1900. It was a focal point in front of the J Building for more than 40 years. It was moved to the backyard of Cottage 16 in the late 1940s after vandals nearly destroyed it. Patients were escorted on walks, rides, and excursions to the state fair and baseball games. (Courtesy of OSA.)

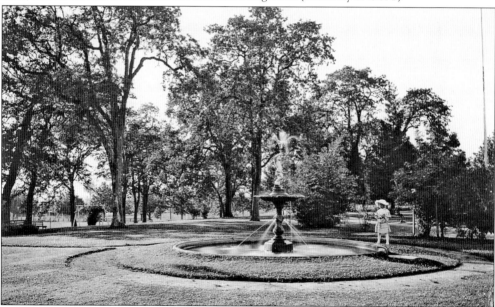

Shortly after the Calbreath family arrived, Helen and Evelene went to the kitchen for a snack. A patient working there grabbed a large knife, held it to the little girl's throat, and threatened to cut her. Calmly, Evelene pushed the hand holding the knife away and said, "No, May. You can't scare me. I know you aren't that crazy." The patient laughed, "You see, Evelene has more sense than anyone here." (Courtesy of OSL.)

Supt. John Calbreath initiated a variety of games, parties, and entertainment for the patients and attendants. Patients used as many as five croquet sets set up on the asylum lawn. Baseball clubs of patients and staff were organized at the Cottage Farm and at the asylum. The first match was played on the front lawn on a Saturday afternoon in August 1901. Patients became avid supporters of their favorite teams. (Courtesy of OSA.)

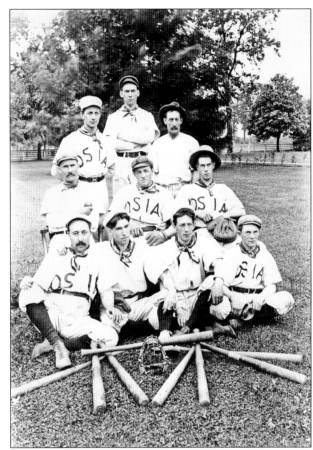

The photograph below shows the 1903 construction of Building 47, on the north side of the J Building. The asylum dances began promptly at 6:30 p.m. and ended at 8:00 p.m. There were four square dances and four round dances, consisting of two dancers doing two quadrilles, two waltzes, and two two-steps. Employees participated in the square dances but not the round dances. (Courtesy of OSH.)

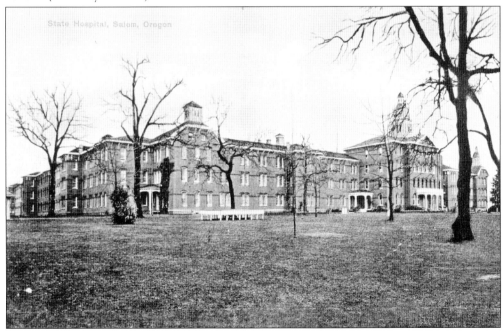

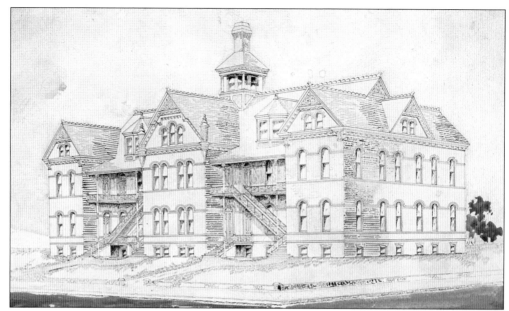

The 1891 legislature allocated $35,000 for a new infirmary. When it was finished, the building had room for 120 patients. It was a two-story brick building with a daylight basement. The infirmary was divided in half, with two wards on each side, to separate those who might be contagious. Food was brought from the kitchen by tunnel and up to the wards via dumbwaiter. (Courtesy of OSA.)

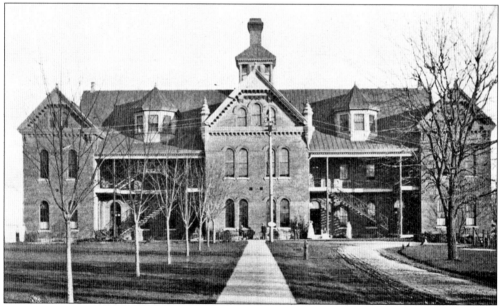

The infirmary is seen here after it was finished. It had walls 16 inches thick and was built southeast of the main building. It had a laundry and a disinfecting room in the basement. Broad iron stairs on the exterior gave access to the separate sides. Hot water radiators provided heat. Disinfectants at that time included carbolic acid, chloride of lime, and charcoal for cesspools, drains, and closets. (Courtesy of OSA.)

As of 1892, there were only two assistant physicians for 794 patients. The physicians, Dr. W.T. Williamson and Dr. L.F. Griffith, made the rounds of the wards every "forenoon" and visited the seriously ill more often. Sanitary rules recommended that patients bathe their entire bodies once a week, and all underclothes were washed and boiled once a week. That year, the Board of Control recommended hiring two more physicians. The hospital had admitted 522 people—359 men and 163 women—between 1891 and 1892. It cost about $2.81 a week to support each patient. Between 1891 and 1892, OSIA spent $1,440 on drugs and $55,868 for food and other supplies. (Courtesy of OSA.)

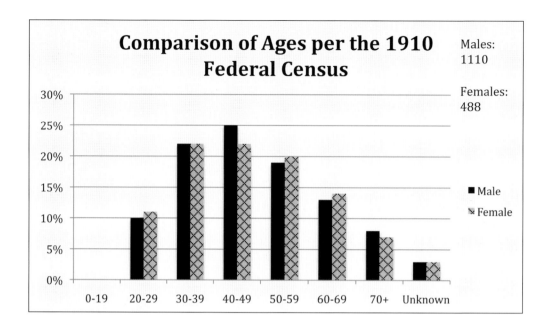

The federal census was conducted at OSIA on May 23, 1910. Dr. R.E. Lee Steiner, age 40, his wife, Belle, age 38, their daughter Rita, age 16, their daughter Barbara, age 14, and their son Milton, age 8, had been living in the building for almost three years. There were 134 staff members living on campus. During the previous two years, 2,660 patients had been received at the asylum. There were 1,110 men and 488 women, for a total of 1,598 patients, on the day the census was taken. The youngest was a 13-year-old boy, and the oldest was a 100-year-old woman. (Both, analysis by the author.)

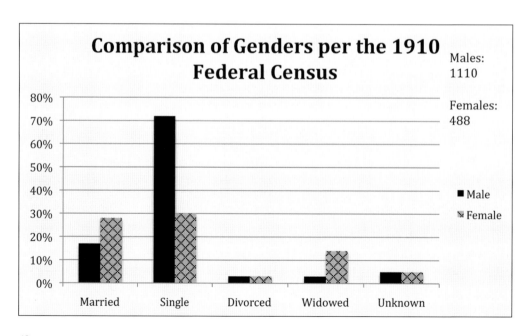

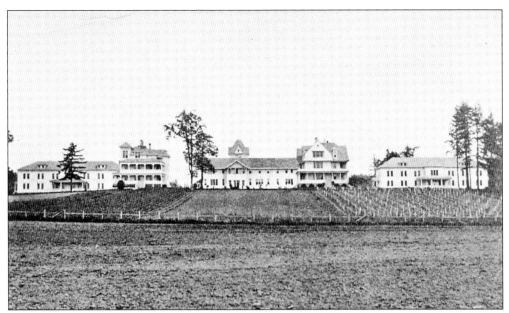

The Cottage Farm dormitory building is seen here in 1908. Dr. Calbreath believed that "As many of the patients as are able to work and can be induced to do so are kept busy, though none are compelled to work against their protest. Physical employment is good for the patients who are strong physically, provided that it is not so disagreeable to them as to cause mental excitement." (Courtesy of OSA.)

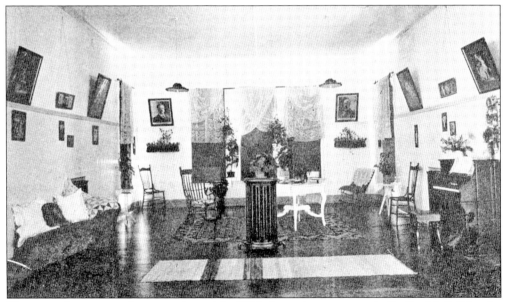

This was a dayroom in the women's ward. In 1904, the asylum sponsored a St. Patrick Ball for the female employees, and more than 60 couples attended. A year later, the Calbreaths sponsored a Valentine's Day dance for more than 100 guests. The ballroom was decorated with evergreens, flowers, potted plants, hearts, and miniature cupids. A midnight dinner was served. (Courtesy of OSA.)

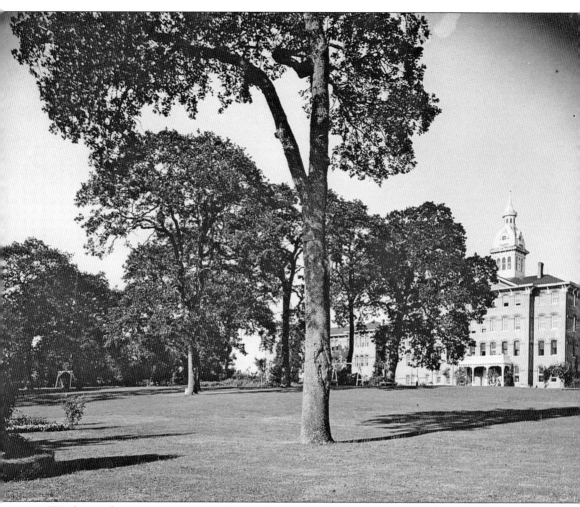
Ward attendants were required to live in the asylum, working six-day weeks and 12-hour days. They earned between $37.50 and $42.50 a month in 1906. Women earned $2.50 less than men for the same work. A stenographer, a gardener, a druggist, and a plasterer each earned $50 a month. Farm workers earned the least, at $25 a month. (Courtesy of OSL.)

The average American household earned $62.50 a month in 1903. Today, that same dollar would be worth almost $26. The highest-paid employees besides Dr. Calbreath and the physicians were the bookkeeper and the engineer, who each earned $100 a month. Physicians earned between $90 and $150 a month. (Courtesy of OSL.)

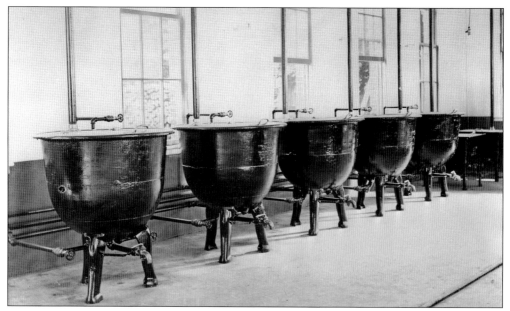

On December 24, 1907, the asylum employees cooked dinner for nearly 1,500 patients. The menu consisted of coleslaw, apples, celery, baked turkey, goose, duck, chicken, dressing, gravy, mashed potatoes, stewed tomatoes, bread and butter, rice pudding, jelly, canned fruit, ginger cake, tea, and milk. It required 1,300 pounds of meat to produce the main course for the 75 dinner tables in the asylum. (Courtesy of OSA.)

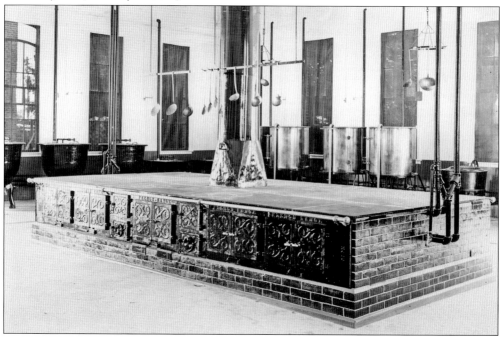

In 1949, it took the following items to cook one meal at OSH: 1,250 pounds of potatoes, 220 gallons of fruit, 220 gallons of vegetables, 1,000 pounds of bread, 300 gallons of milk, 1,200 pounds of meat, 350 gallons of coffee or tea, 2 sacks of flour for gravy, 200 pounds of butter or margarine, and 400 pies or 500 pounds of cake. (Courtesy of OSA.)

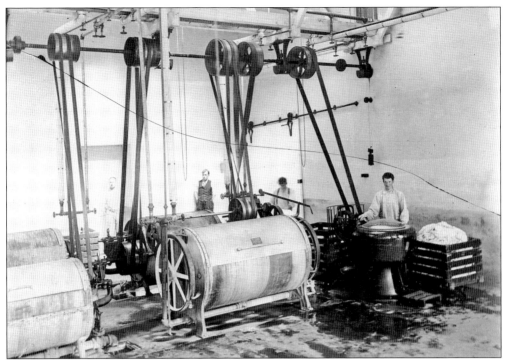

The laundry room was originally in the basement of the main part of the J Building. In the beginning, a single paid employee supervised almost a dozen patient assistants to wash the asylum linens and all the patient and employee clothing. By the end of 1915, there were four employees and 46 patients working to clean 500,000 pieces of laundry a year. (Courtesy of OSA.)

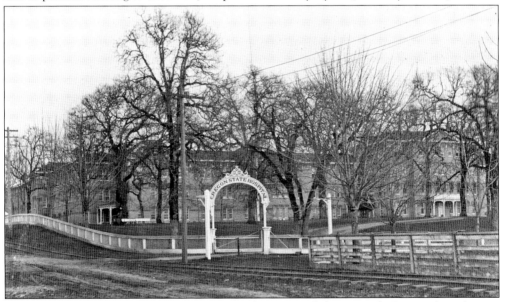

This sign was the first thing patients saw as they entered the grounds. It must have been a frightening time, as contagious disease was always a problem in large institutions. OSIA suffered a typhus outbreak in 1902, when 17 patients and five attendants became ill from contaminated water traced to Salem's Mill Creek. (Courtesy of OSL.)

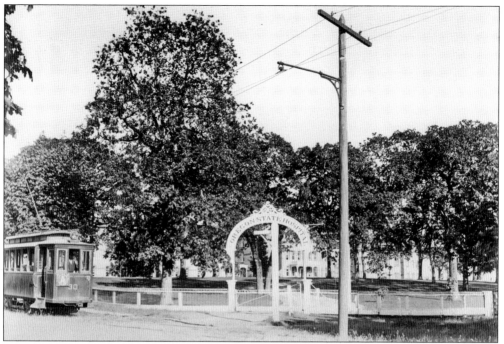

On August 1, 1901, the Calbreath family sponsored "a gay trolley party" for their invited guests. The asylum orchestra played songs as the electric trolley cars carrying the guests traveled from place to place around Salem. It was a lovely summer evening, and they all returned to the asylum afterwards for a late dinner. (Courtesy of OSA.)

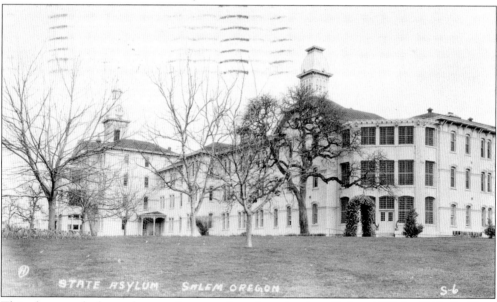

This photograph shows the new front porch and portico installed in 1910. In 1915, Building 48, the last extension on the north side of the J Building, was constructed, and the corners at the west facade of the building were filled in. Small areas at the rear of each building segment were expanded into bathrooms. This postcard had a postmark of 1925. (Courtesy of WHC, No. 2011.006.0672.)

Three

THE GOLDEN YEARS

Dr. R.E. Lee Steiner served as superintendent from January 1, 1908, to June 30, 1937. He was 38 years old, and his wife, Belle, was 36 when he arrived. They had three children: Rita, age 14; Barbara, age 12; and Milton, age 5. On February 25, 1917, an attendant was killed in a riot inside the forensic ward. Major changes and improvements occurred during this time. The largest building project was the Dome Building, which was partially completed in 1912 and finally finished in 1918.

On February 25, 1913, the name was changed from the Oregon State Insane Asylum to the Oregon State Hospital, according to House Bill 433. About the same time, the Oregon Legislature passed Senate Bill 109, directing the hospital to build a crematorium to exhume and cremate any unclaimed bodies from the asylum cemetery to make room for additional buildings. The last body was exhumed in March 1914. From that point on, the hospital was required to cremate every body not claimed by the family.

A major improvement was a change in the law allowing patients out of the hospital on a parole system. The Eastern Oregon State Hospital opened in Pendleton in 1913, relieving some of the overcrowding at OSH for about a year. Dr. Steiner began an intensive campaign to transport resident aliens back to their countries of birth when he became superintendent. In December 1913, he and three other officials escorted 25 Chinese men back to China. The patients rode steerage at $46 per person, and the officials went first class at $262.50 each. Every patient was given $59.36 as relocation expenses when they arrived. Total cost for the trip was $3,348.

From May 1919 to February 1920, Dr. Steiner became warden of the penitentiary and Dr. L.F. Griffith assumed command of OSH. By 1923, overcrowding was a severe problem, and the hospital sustained a $25,000 budget cut. While Dr. Steiner was superintendent, he built a new chapel with seating for 1,000 people, which cost $50,000. He modernized the wards for the criminally insane, added firefighting equipment, and constructed new roads throughout the OSH campus and Cottage Farm property.

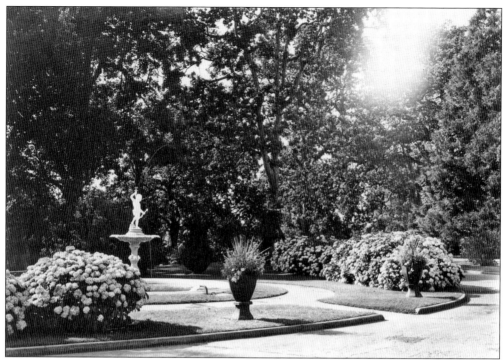

By 1914, there were 1,576 patients and 209 employees in the hospital, and care cost $14.64 per month per patient. Treatment was successful about 40 percent of the time, and the patients were released. There were 215 employees listed on the biennial report, and the hospital was costing the state about $9,700 a month. Any Oregon resident ruled insane or "an idiot" was entitled to admission in the state hospital. (Courtesy of OSL.)

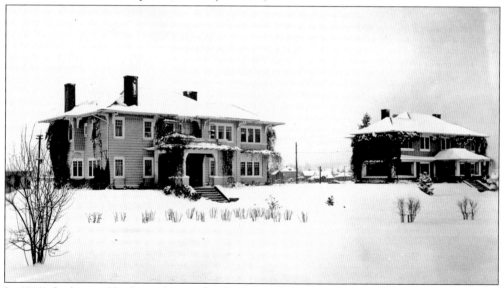

In 1909, the hospital built two houses for the hospital physicians. It cost $3,205 for furnishings, including furniture, floor coverings, mattresses, curtains, and other decorations. The houses were designed and built by Louis Hazeltine, a local architect. Today, the houses have been refurbished and are used for transitional patient housing. (Courtesy of OSA.)

Belle Steiner was an avid gardener, and, in collaboration with her husband, she designed the many gardens around the hospital grounds. Using patient labor, they were very particular about every tree and bush, installing protective latticework around them. She also encouraged the display of patients' artwork in the hospital, including many murals painted on walls in the halls and wards. (Courtesy of OSA.)

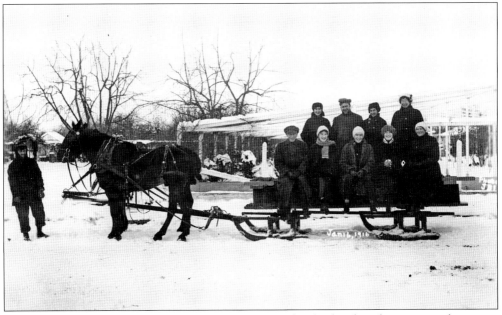

By 1916, there were 1,248 patients living in OSH. Besides sleigh rides when it snowed, patients participated in a weekly patients' dance, trips to the circus, religious services on Sundays, band concerts, frequent walks, fairs, parades, and games on the wards. A weekly motion picture show provided welcome entertainment. (Courtesy of OSA.)

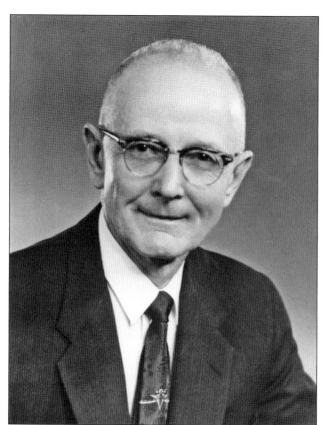

Supt. R.E. Lee Steiner posted rules for employees that included the following: all attendants shall be persons of good character, of even temper, and of sound judgment, and shall avoid all rudeness, undue familiarity, or use of disrespectful terms. (Courtesy of OSH.)

Below is the superintendent's home, built in 1908. It was on the north side of Center Street until it was demolished to make room for additional buildings. OSH supported the superintendent and other major employees with housing, food, and other amenities. Superintendents were appointed for a term of four years and had to be licensed physicians who had practiced medicine for at least five years. (Courtesy of OSL.)

Male patients were assigned to widen and improve Asylum Avenue in front of the asylum. This 1912 photograph shows patients using hand implements to grade the street, spread a layer of gravel on top of the dirt, and fill in potholes. Working the patients hard during the day was a way to keep them quiet at night. (Courtesy of OSH.)

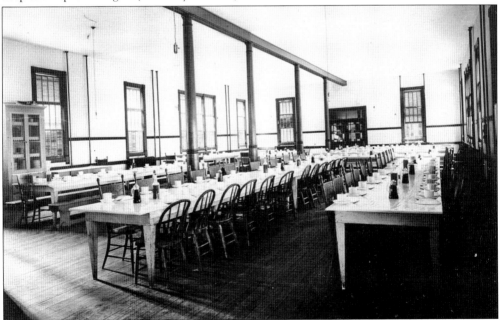

In 1911, a dispute erupted at the Cottage Farm. A black couple was hired to work in the dining hall. A group of 10 employees signed a protest saying, "We the employees of the hospital farm consider it an imposition and disgrace to have colored people working in positions that they do and we object strenuously." Dr. R.E. Lee Steiner subsequently fired several employees, and the couple continued their employment. (Courtesy of OSA.)

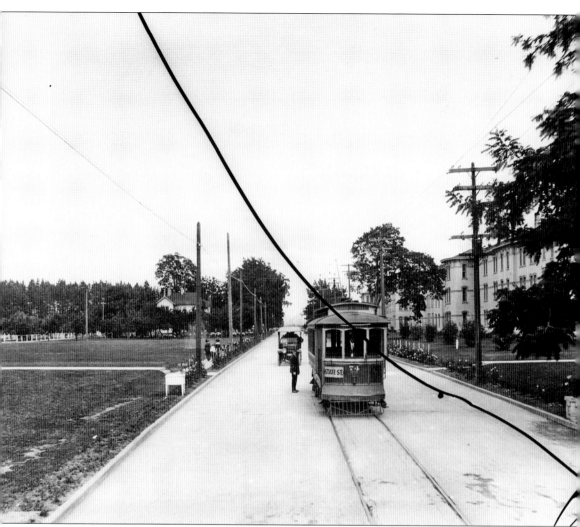

In the upper left is a white fence enclosing the asylum cemetery. First established in 1883, it contained almost 1,600 unclaimed bodies by 1913. The first death at the hospital took place two days after it opened. An unclaimed body was dressed in a white muslin shroud, placed in a plain brown coffin, and buried. The grave was marked with the name and date of death. An early *Oregon Daily Statesman* article described the cemetery: "On Decoration Day, the little inmates of the orphans' home, under the supervision of their matron, gathered a lot of wildflowers and decorated the graves of the insane dead. . . . The Deed was a worthy one, and to the little ones is due a great deal of credit for doing this act of mercy to the unfriended dead." By the end of 1914, all the bodies had been exhumed and cremated. The cremains were eventually stored in a vault created where the pond had been, at the west end of the lawn in front of the J Building. (Courtesy of OSA.)

MISCELLANEOUS DATA

Acreage Owned or Leased

Acreage owned: *Acres*
- Cottage farm 917.85
- Main building 253.526

Total owned1,171.376

Acreage leased 225.85

Grand total1,397.226

Acreage Used as Follows

- Alfalfa 17.
- Barley 30.
- Beans, navy 14.
- Buildings, grounds and roadways 110.
- Cane fruit 13.
- Clover 51.
- Hay, oats and vetch.... 206.
- Hay, cheat 47.
- Kale 16.
- Oats 235.
- Orchard 124.
- Pasture hill 20.
- Peas, Canadian 10.
- Potatoes 214.
- Strawberries 23.50
- Stubble ground, etc. .. 128.726
- Sweet clover 4.
- Vegetables 134.

Total1,397.226

Farm Products

October 1, 1932, to June 30, 1934

DAIRY DEPARTMENT

- Beef, 16,685 pounds
- Calves, 84
- Hides, 649 pounds
- Manure, 2,000¼ tons
- Milk, 194,629 gallons
- Veal, 2,097 pounds

FARM AND GARDEN DEPARTMENT

- Asparagus, 4,663 pounds
- Barley, 72 tons
- Beans, dry, 17,409 pounds
- Beans, green, 59,746 pounds
- Beets, stock, 86,000 pounds
- Beets, table, 82,153 pounds
- Brussel sprouts, 2,837 pounds
- Cabbage, 326,839 pounds
- Cantaloupes, 486 dozen
- Carrots, stock, 11½ tons
- Carrots, table 355,916 pounds
- Cauliflower, 9,625 pounds
- Celery, 1,106 dozen bunches
- Cheat seed, 31 pounds
- Corn, sweet, 17,857 dozen
- Corn, pop, 1,680 pounds
- Cucumbers, 24,904 pounds
- Cucumbers, pickles, 12,600 pounds
- Dill, 45 pounds
- Ensilage, 1,028 tons
- Forage, 340 tons
- Greens, 145,628 pounds
- Hay, baled, 538½ tons
- Horseradish, 169 pounds
- Kale, 225½ tons
- Lettuce, 27,198 pounds
- Manure, 353½ tons
- Melons, musk, 10,954 pounds
- Oats, 5,583 bushels
- Onions, green, 40,107 pounds
- Onions, dried, 35,236 pounds
- Parsnips, 128,727 pounds
- Peas, green, 49,521 pounds
- Peppers, green, 4,975 pounds
- Potatoes, 28,394 bushels
- Pumpkins, 26,405 pounds
- Radishes, 4,672 pounds
- Rhubarb, 48,782 pounds
- Salsify, 420 pounds
- Sage, 185 pounds
- Squash, small, 17,790 pounds
- Squash, table, 120,174 pounds
- Spinach, 10,736 pounds
- Straw, 88 tons
- Strawberries, 15,771 pounds
- Swiss chard, 1,830 pounds
- Tomatoes, 331,588 pounds
- Turnips, 101,311 pounds
- Turnips, rutabaga, 34,221 pounds

HOG DEPARTMENT

- Cracklings, 3,170 pounds
- Lard, 36,172 pounds
- Manure, 199 tons
- Mutton, 548 pounds
- Pork, 113,186 pounds

ORCHARD DEPARTMENT

- Apples, eating and cooking, 14,054 bushels
- Apples, crab, 38 bushels
- Blackberries, 13,007 pounds
- Cherries, 13,762 pounds
- Cider, 3,761 gallons
- Currants, 2,540 pounds
- Filberts, 170 pounds
- Gooseberries, 4,740 pounds
- Grapes, 22,700 pounds
- Honey, 240 pounds
- Loganberries, 12,510 pounds
- Peaches, 259 bushels
- Pears, 1,101 bushels
- Plums, 38 bushels
- Prunes, fresh, 535 bushels
- Prunes, dried, 92,403 pounds
- Quince, 20 bushels
- Raspberries, red, 6,964 pounds
- Vinegar, 6,335 gallons
- Walnuts, black, 524 pounds
- Walnuts, English, 4,530 pounds
- Youngberries, 455 pounds

POULTRY DEPARTMENT

- Broilers, dressed, 4,793 pounds
- Chicks, day old, 4,650
- Eggs, 86,131 dozen
- Eggs, hatching, 337 dozen
- Ducks, dressed, 280 pounds
- Geese, dressed, 300 pounds
- Guinea pigs, 22
- Hens, dressed, 16,447 pounds
- Manure, chicken, 108 tons
- Manure, straw, 2,010 tons
- Turkeys, 1,442 pounds

This report shows the amount of produce supplied by the Cottage Farm between 1932 and 1934. It also reports the amount of acreage owned and leased by the hospital and how much was allocated to each product. By 1949, the Cottage Farm was producing 112,029 gallons of milk, 171,262 pounds of pork, 15,698 pounds of chicken, 84,682 dozen eggs, 6,992 pounds of turkey, 374 tons of fruit, 980 tons of vegetables, 814 tons of hay, and 111 tons of grain. The hospital used $17,500 per month of farm produce. Dr. R.E. Lee Steiner wrote the following in 1918: "Idleness, either enforced or voluntary, is unwholesome to an extreme degree even with the sane; it is doubly so with the insane crowded together where their morbid tendencies, lack of control and irritability react upon one another increasing their restlessness and multiplying their tendencies toward noise and violence." That same year, patients strung 38 tons of beans for a local cannery, netting the hospital $1,513. (Courtesy of OSA.)

The Cottage Farm operation provided occupational therapy for the patients and significantly reduced the cost of maintaining the facility. By the end of 1923, it was estimated that the farm produced $213,644 in meat, dairy, and produce for consumption at the hospital as well as a surplus for other institutions. A cold storage plant produced 100,000 pounds of ice and helped preserve the meat and produce. (Courtesy of OSH.)

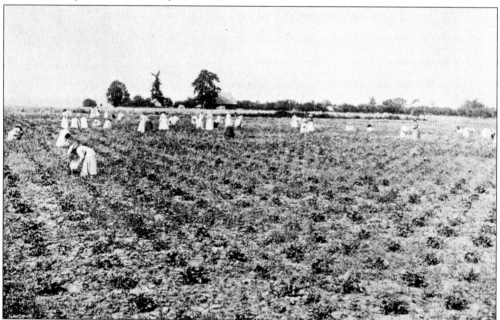

Female patients were assigned to pick the berries and fruits as needed. The farm produced everything eaten at the 1916 Thanksgiving feast except the coffee, tea, macaroni, cheese, and butter. The meal included potatoes, salad, turkey, chicken, duck, bread, soup, green beans, applesauce, giblet stew, rice pudding, pumpkin pie, fruitcake, and cranberry sauce. (Courtesy of OSA.)

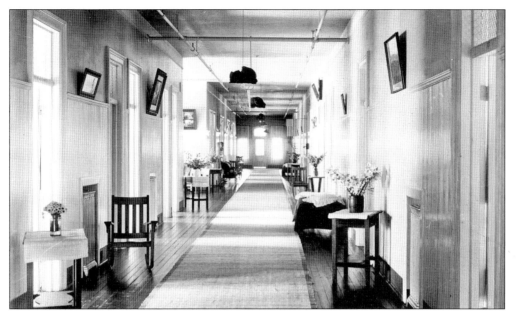

The ladies' wards were neater than the men's and decorated with flowers, carpeting, handmade pillows, curtains, and quilts. Their wards were constructed the same as the men's, with long hallways, small sleeping rooms on each side, and small parlors where the women could socialize. Glass allowed attendants to see inside the sleeping rooms. Patients were locked in their rooms at night and released by the attendants in the morning. (Courtesy of OSA.)

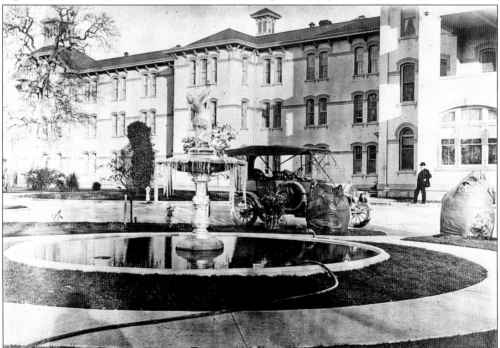

In 1910, Dr. R.E. Lee Steiner requested funds to purchase a car for his use as the superintendent. The request was refused. A subsequent investigation revealed that he had spent $2,198 of asylum funds on a new car anyway. (Courtesy of OSA.)

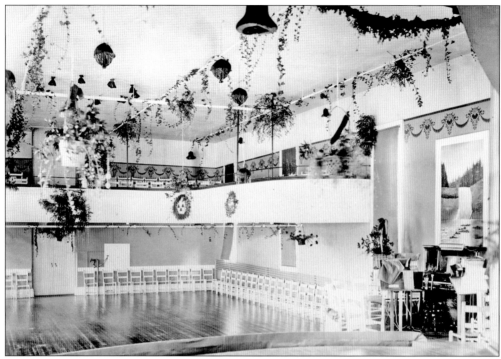

The auditorium could hold 600 people and was used for shows, religious services, dances, and other forms of recreation. About 200 guests attended the St. Patrick's Day dance on March 20, 1908. Nearly everyone wore something green—a ribbon, a necktie, a belt, a flower, or something. Even the punch was green. (Courtesy of OSA.)

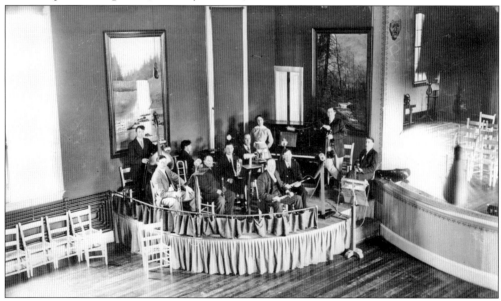

The asylum band provided musical entertainment at the hundreds of social gatherings that took place at OSIA through 1940. In August 1901, they performed the popular songs "Jolly Knight" and "Shuffling Pete" at a gathering of Salem citizens. Various members played instrument solos appropriate to the holidays. (Courtesy of OSA.)

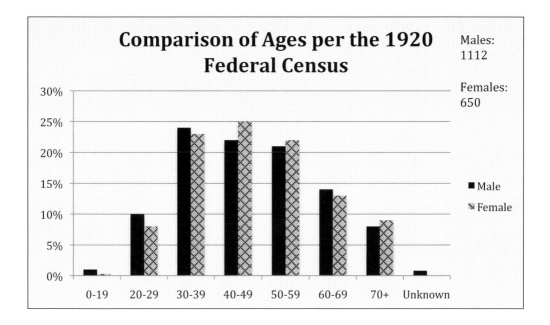

The 1920 Federal Census was conducted at OSH by Stephen F. East on January 2, 1920. There were a total of 1,762 patients and 216 employees. There were now four physicians, in addition to Supt. R.E. Lee Steiner, and a dentist/druggist. The youngest patient was a 17-year-old boy, and the oldest was a 94-year-old woman. Minorities included one Filipino man, one Hindu man, two Chinese men, one Chinese woman, five Japanese men, nine black men, and one black woman. There were now 17 divorced women and 15 divorced men. Single men (76 percent) far outnumbered single women (33 percent), with 50 percent of the women being married and only 18 percent of the men. (Both, analysis by the author.)

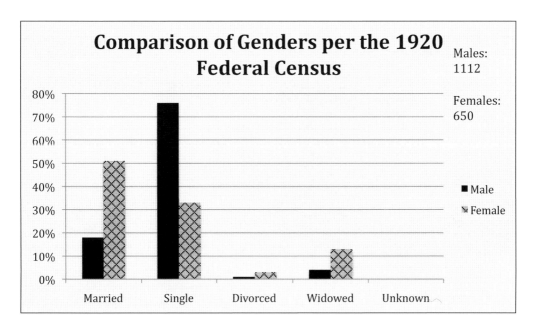

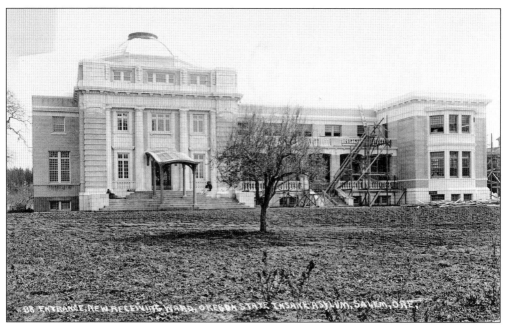

In 1912, the Dome Building was built, facing west and serving as a medical and surgical hospital for the asylum. The south wing, for treating women, and the surgery center were completed first. It had a splendidly equipped surgery that soon proved a successful addition to the asylum. (Courtesy of WHC, No. 2011.006.0781.)

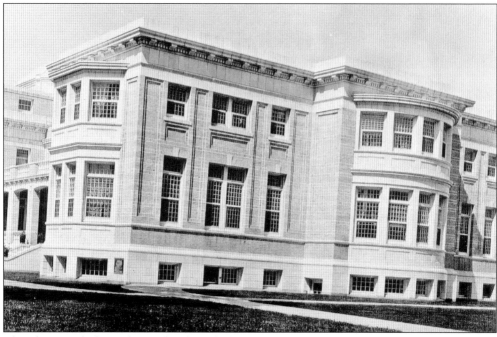

This photograph shows the south side of the building. The bay windows were designed to provide as much natural light as possible for the surgical center. Between 1917 and 1941, there were 509 people sterilized as part of the eugenics program in this operating room. Of those sterilized, 59 percent of them were women or young girls. (Courtesy of OSL.)

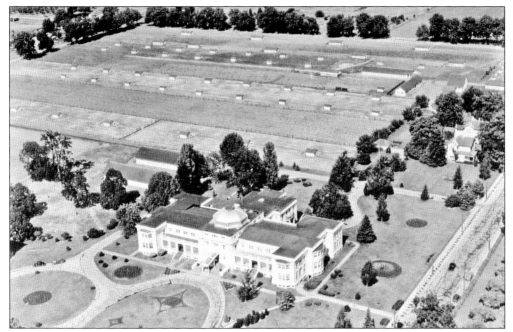

The north wing of the Dome Building was finished in 1918. It served as the hospital's administration center until Siskiyou Hall was opened in 1950. Edgar M. Lazarus (1868–1939), a prominent Portland architect, designed the building. Every new patient entered through this front door. It was completed at a cost of $60,000. The superintendent's house is behind it in the upper right corner. (Courtesy of SPL.)

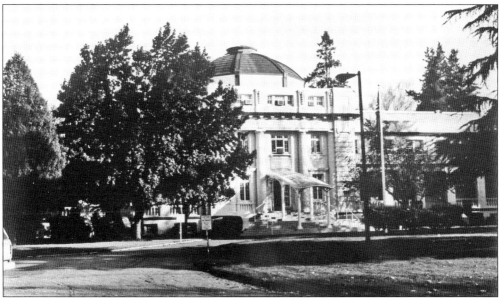

By 1940, the Treatment and Psychopathic Hospital, known as the Dome Building, had about 160 patients occupying the treatment and hospital wards. There were 9 physicians, including Supt. R.E. Lee Steiner, 306 employees, and 2,659 patients living on campus that year. It was costing the state $13.88 per month for each patient. During the previous two years, 644 patients had died and 1,061 had been released. (Courtesy of OSL.)

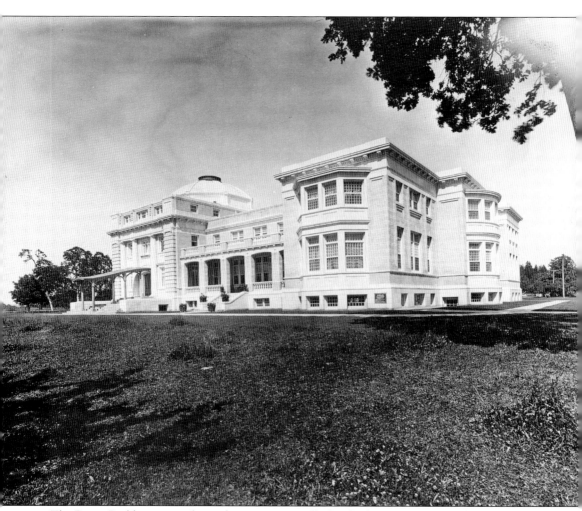

The Dome Building is seen here when it was partially finished in 1912. It sat on the north side of Center Street but was connected by one of the many tunnels running from building to building. The two-story building has a center open area rising almost three stories and a decorative colored-glass, saucer-shaped roof. Inside the open area, metal railings lined the circular stairway, winding around the domed area and mosaic floor tiles, creating a pleasing and attractive public entrance. Even with the addition of this building, the hospital was so overcrowded that beds were placed in corridors and smoking rooms on the wards. The electrical system was updated in 1992. Today, the building houses administrative offices of the state corrections system. (Courtesy of OSL.)

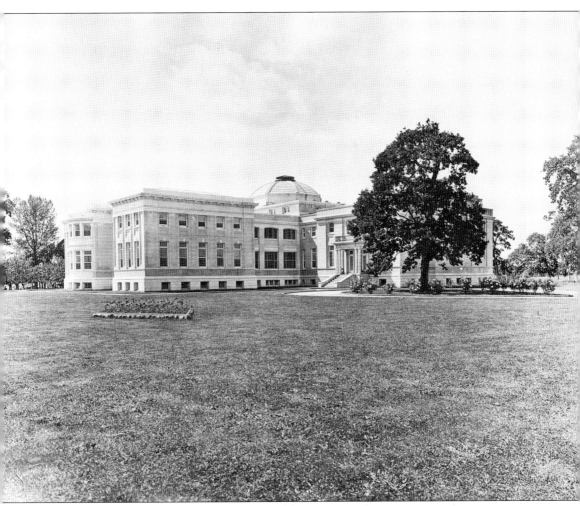

This photograph shows the back of the Dome Building in 1912, when it was opened as a receiving ward for the asylum. It was later used for administration and then corrections. Its unique shape has helped define the campus since that time. For the next 30 years, the building received, tested, and diagnosed more than 500 new patients every year. The new building was equipped with all the modern hydrotherapeutic apparatus and appliances for special lines of treatment. It was a hospital in the proper sense, where the insane could have their physical illnesses treated as well as their mental illnesses. (Courtesy of OSL.)

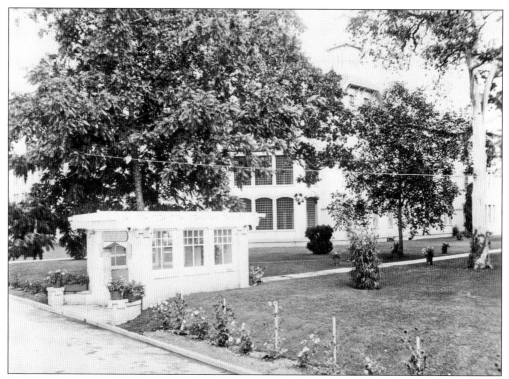

By 1924, there were 1,864 patients, 221 employees, 5 physicians besides the superintendent, a druggist, a bookkeeper, a chief engineer, a Cottage Farm engineer, a steward, a person in charge of the commissary, a supervisor, a head matron, a supervisor at the Cottage Farm, and a matron at the Cottage Farm. It cost $17.28 per patient per month, for a total of $855,485 for the past two years. (Courtesy of OSA.)

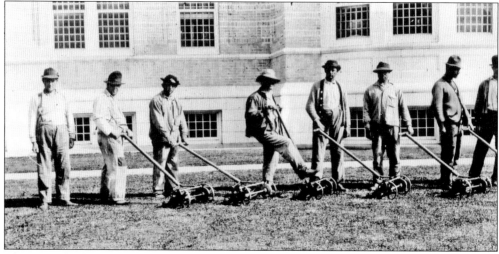

These men had jobs pushing lawn mowers to keep the grass down on the acres of lawn outside the Dome Building. It required a virtual army of patients to tend the trees, flowers, and bushes and to perform other duties associated with the hospital landscaping. In addition, the florist department produced potted plants and cut flowers for the wards, dining rooms, reception rooms, and hallways throughout the campus. (Courtesy of OSL.)

Roy DeAutremont, a convicted bank robber, was sent to prison in 1927 and then transferred from the prison to the hospital in 1949, where he was given a lobotomy. After the surgery, the doctor wrote, "Patient is quieter and less untidy. Improvement estimated at 25 percent." Dr. York Herron was hired in 1947 to perform lobotomies at a cost of $200 each. The operation consisted of trephining the skull in the temporal region with a thin, knife-like blade about four inches in length. It was inserted into the frontal lobe of the brain, cutting from below upwards and severing the nervous pathways from the frontal lobe to the other parts of the brain. It brought about an immediate change of personality and habit patterns. It was often recommended for patients who needed to be more cooperative, and it relieved ward personnel from having to keep them in restraints. Between 1947 and 1950, a total of 45 prefrontal and 13 trans-orbital lobotomies were performed at OSH. By 1954, OSH had performed 135 brain surgeries. The surgery was banned in Oregon in 1981. By then, about 50,000 people had been lobotomized in the United States. (Courtesy of OSA.)

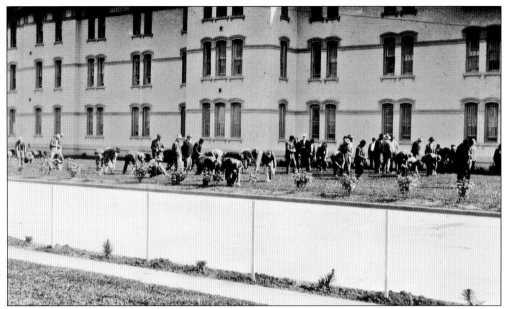

Supt. R.E. Lee Steiner wrote in 1920, "The beautiful lawns, flowers, the extensive orchards, vineyards, truck gardens and intensively cultivated fields show but a small portion of the men patients' labors. The women are employed in the laundry, sewing room, dining rooms, in gathering berries and preparing vegetables, and in the canning department, the duller ones being stimulated to effort by attractive work such as basketry, needlework and rug making." (Courtesy of SPL.)

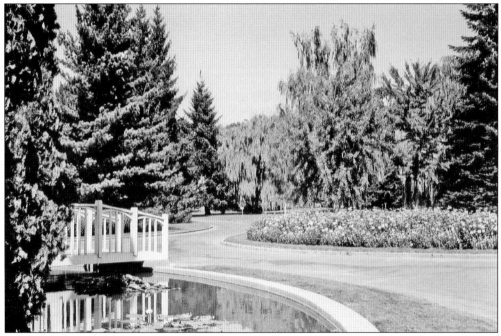

The hospital landscaping and parklike atmosphere was a unique part of the therapeutic philosophy underlying OSH history. About 20 acres in the western front of the J Building were deliberately left as an area the patients and staff could enjoy. Other smaller areas were designated as parks throughout the campus. (Courtesy of OSH.)

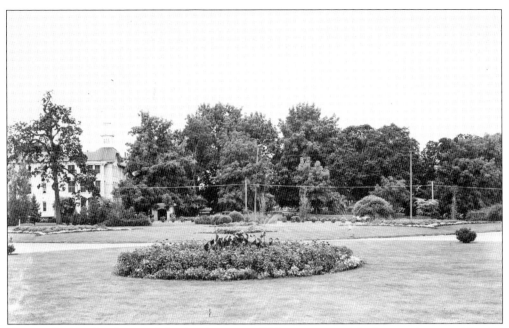

Thomas Kirkbride advocated the development of "pleasure grounds" where patients could enjoy the outdoors on a daily basis. Unfortunately, most patients could only look at the gardens from the confines of their locked wards. Only about a quarter of the patients were granted access to the grounds, and most had to be escorted by attendants. (Courtesy of OSL.)

Drinking water for OSH came from five wells drilled 120 feet deep that produced 1,000 gallons a minute in 1940. Irrigation water was piped directly from Mill Creek. It was highly polluted and could not be used anywhere else. Greenhouses on campus provided work for the patients and plants for landscaping. (Courtesy of OSL.)

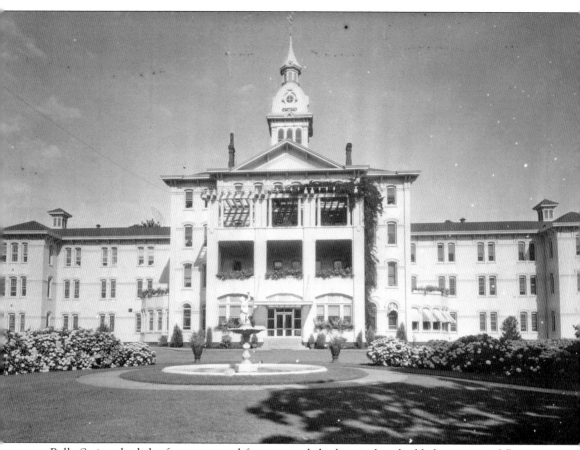

Belle Steiner had the fence removed from around the hospital and added a variety of flowers, bushes, and trees to create a more welcoming appearance. She was particularly fond of roses. In 1910, Dr. Steiner had the entire hospital painted white, added a new portico to the front entrance, and bricked in the corners of the wings to provide more room for patients. (Courtesy of OSL.)

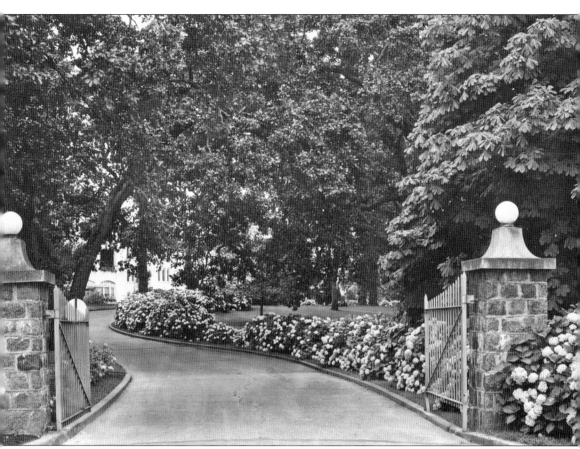

This entrance with brick posts and iron fencing was one of a pair used to mark the entrances on the south side of Center Street leading to the J Building. One pair still stands at the corner of Center and Twenty-fourth Streets, and a second pair stands at the corner of Twenty-fourth Street and Greenway Drive. (Courtesy of OSL.)

This photograph provides a contrast between the public appearance and what was occurring inside the walls of OSH. In his 1928 superintendent's report, Dr. Steiner wrote, "Sterilization of the instance of childbearing age is very important, not only to prevent the development of insanity in the offspring, but young women recovered from one attack greatly increase the liability of another breakdown if subjected to the stress of childbearing." There were 28 sterilizations, 5 vasectomies, 6 castrations, and 6 other sterilization surgeries performed between 1926 and 1928. He continued, "All of these were by the direction of the State Board of Eugenics. No untoward or unfavorable results have occurred, and the operations have been beneficial in all cases." (Courtesy of OSA.)

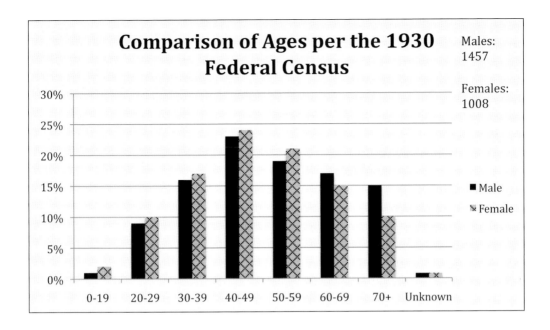

Priscilla E. Fry conducted the 1930 Federal Census at OSH on April 29, 1930. There were a total of 2,465 patients. Nearly 19 percent of the women and 25 percent of the men named in the 1920 census were still patients in 1930. There were 193 employees—113 men and 80 women—10 of which were professional staff. The youngest patient was a 14-year-old girl, and the oldest was a 91-year-old man. There were now 35 male and seven female minorities. Of those, 12 were Japanese, 10 were black, and 9 were Chinese. The number of divorced patients had increased substantially. There were now 77 (five percent) divorced men and 63 (six percent) divorced women. (Both, analysis by the author.)

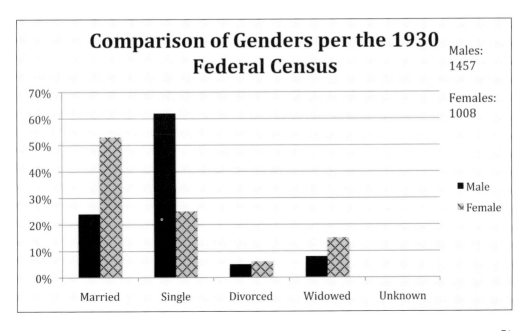

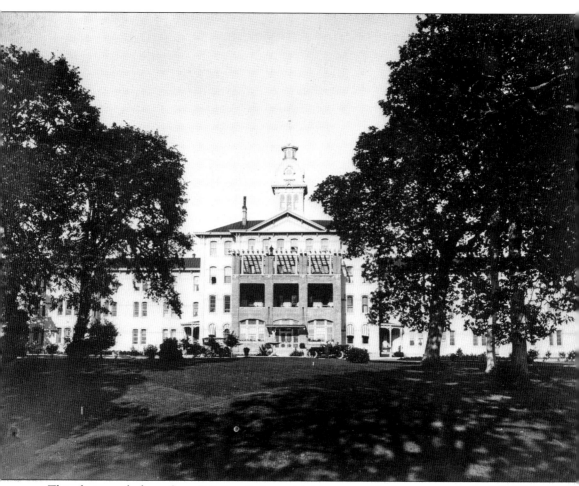

This photograph shows Supt. R.E. Lee Steiner with his car outside the entrance to the J Building in 1937. Patients were allowed to have visitors Monday through Friday from 10:00 a.m. to 12:00 p.m. and from 2:00 p.m. to 4:00 p.m. Immediate relatives were also permitted to visit on Sundays from 10:00 a.m. to 12:00 p.m. There was a daily average of 2,528 patients in the hospital. (Courtesy of OSA.)

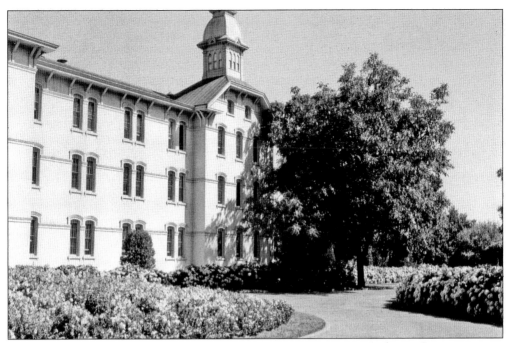

By 1914, OSH had instituted a parole system, allowing patients to leave the hospital on a temporary basis. Prior to that date, the only way they could leave was to be labeled cured. The system was successful, and 184 were allowed on parole in the first year. By 1936, more than 500 patients had left permanently and were living successfully with family or friends. (Courtesy of SPL.)

A severe epidemic of influenza killed 67 patients in 1937. By 1938, OSH had begun an intensive program of insulin and Metrazol shock therapy, especially on patients with dementia praecox or schizophrenia. Alcoholic admissions had increased to 20 percent. The hospital was so overcrowded that beds had to be placed in the hallways and exercise courts. (Courtesy of OSA.)

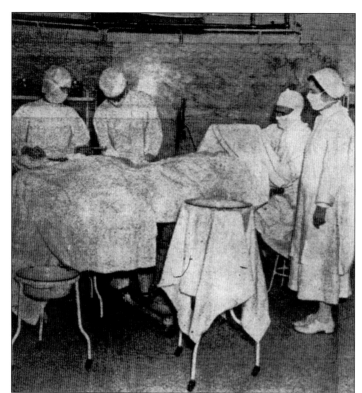

This 1936 photograph shows the inside of the Dome Building during a surgery. According to the Oregon Board of Control records, during the previous two years, hundreds of minor and major surgeries were performed in this room, including 48 sterilizations for the Eugenics Board. (Courtesy of ORE, June 21, 1936.)

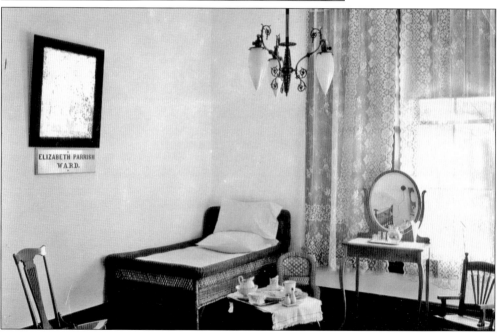

By 1942, Oregon law allowed spouses of patients to get divorces based on the grounds of insanity when the spouse was confined in one of the Oregon institutions. The patient had to be ruled insane for at least five years previous to the divorce. However, the judge granting the divorce could require the ex-spouse to pay maintenance charges for the life of the patient. (Courtesy of OSL.)

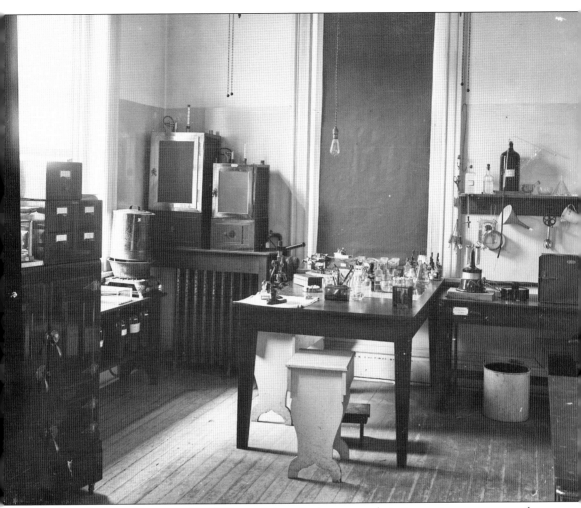

Insulin, a hormone discovered in 1922, was injected subcutaneously in increasing amounts until a patient experienced a seizure and a coma lasting about four hours. Usually, the patient received many such treatments before they were cured, or until the physicians pronounced the patient incurable. The massive amounts of insulin brought the patient very near to death by starving the brain cells of the sugar necessary to survive. Autopsies of patients treated with insulin showed widespread degeneration and necrosis of nerve cells. Medical and surgical supplies and equipment for the same two years amounted to $2,557, with a total cost of $14,050 for the department. In addition, a hospital ambulance was purchased for $2,480. By 1940, medical supply costs had risen to $18,798 for the last biennium. Between 1934 and 1936, a total of 557 patients died in OSH. (Courtesy of OSA.)

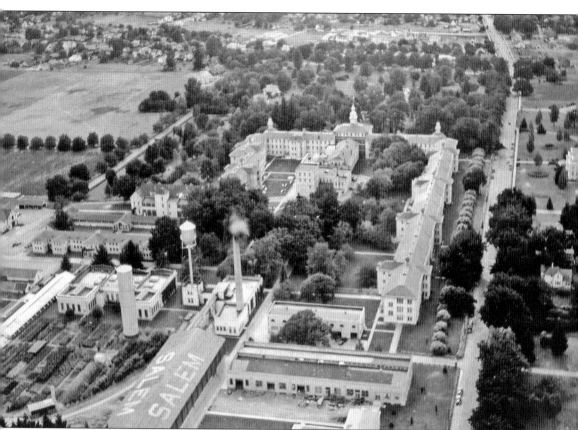

In 1910, Supt. R.E. Lee Steiner had an incinerator installed. "Steiner's Chimney" was originally built to burn infectious waste products. In 1913, the legislature directed OSIA to exhume all the bodies in the asylum cemetery to make way for a new building. The last body was exhumed in March 1914. A total of 1,539 bodies were cremated and stored in cans, soldered shut, and stored away. The shape of the main hospital structure (the J Building) and other hospital buildings are clearly seen in this 1940 overhead photograph. The men's ward to the north extends farther than the women's wards. The hospital kitchen is in the middle, directly behind the cupola. Steiner's Chimney, the incinerator smokestack, has a puff of smoke above it. The water tower is to the south of the smokestack. The fuel shed has the word "Salem" stenciled on each side of the roof. Center Street extends east and west along the right side of the photograph. (Courtesy of SPL.)

Shock therapy was divided into two different categories: convulsive shock and insulin shock. Convulsive shock therapy was divided into electric shock, electro narcosis, Metrazol, and hypnosis. Insulin shock involved giving the patient nearly lethal doses of insulin to induce a coma. Risks included convulsions, coma, and death. Mortality rates ranged from one to 10 percent. (Courtesy of ORE, May 1, 1938.)

In 1948, OSH began reporting the number of shock therapies administered to patients. Electroshock was administered 6,834 times, and 323 Metrazol injections were given. By 1956, the Metrazol injections had risen to 682. Insulin injections had increased to 8,440, and electroshock had been administered 16,378 times. (Courtesy of ORE, May 1, 1938.)

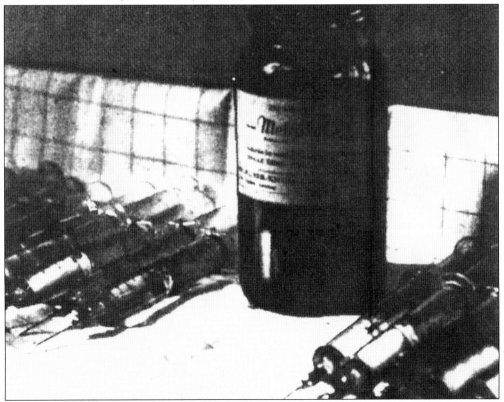

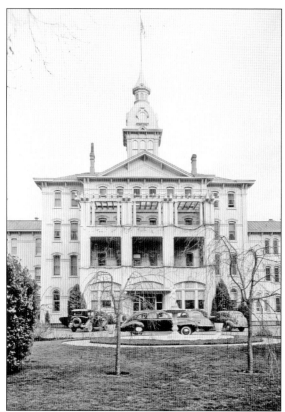

Prior to 1949, it only took one complaining witness to cause a person to be arrested, brought in front of a judge, and committed to OSH. The law changed in 1949, requiring two witnesses and giving the accused the right to appoint his own examining physician and request a defense attorney. (Courtesy of SPL.)

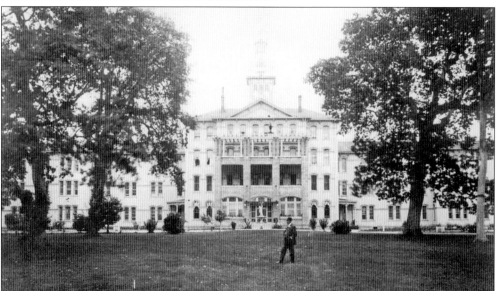

Dr. R.E. Lee Steiner strolls in front of the hospital about 1937. The last two years he was superintendent, he authorized $100,184 in capital outlay, spending $7,343 on household furniture, $5,653 on medical equipment, and $8,000 to buy additional land. He built an additional physician's home and upgraded the basements in the nurses' home and in wards 39 and 40, under the J Building. (Courtesy of OSA.)

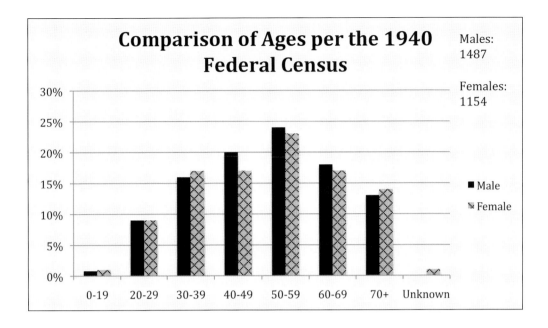

Orel A. Davidson conducted the 1940 federal census at OSH on May 13, 1940. There were a total of 2,641 patients. In addition to Supt. John C. Evans, there were nine physicians and 306 employees. A total of 49 percent of the women and 24 percent of the men were married, and eight percent of the women and six percent of the men were divorced. In the previous two years, 70 percent of the male admissions had syphilis, and 20.41 percent were alcoholics. More than 5,100 patients were received between 1938 and 1940. There were 51 men in the criminally insane ward, 26 of whom had been transferred directly from the penitentiary. Younger patients were housed with the elderly and served as helpers. (Both, analysis by the author.)

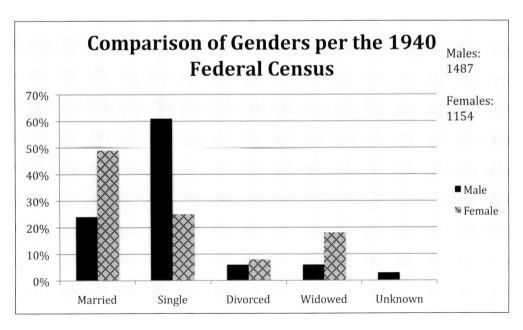

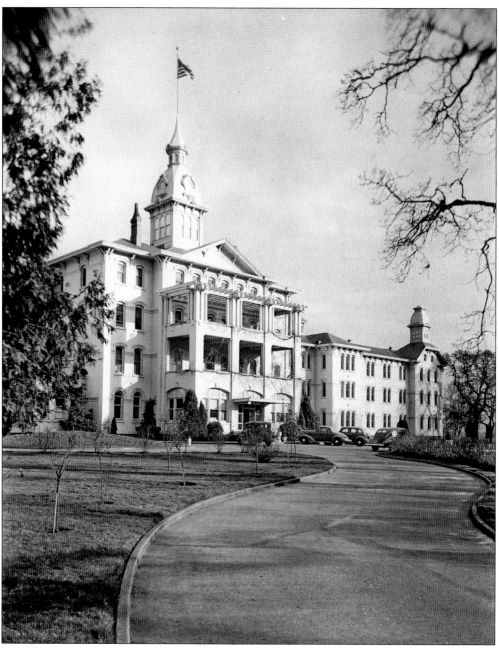

By 1949, it cost an average of $53 a month per patient. Food cost $20,000 a month, and OSH used $17,500 a month of its own farm produce to feed the patients. Between 1939 and 1951, there was a substantial increase in the quality of food, raising the cost from $287,468 to $1,062,150. The Cottage Farm program was eventually surrendered to another institution in 1963 because of the significant decrease in patients. By 1953, much of the J Building was structurally unsound and in need of repair. A 1953 fire marshal's report stated, "The old center section of this building housing some of the offices, attendants' quarters, library, auditorium, and kitchen is the most hazardous section of the structure—the auditorium being particularly hazardous and inadequate." (Courtesy of SPL.)

Four

TRIUMPHS AND TRAGEDIES

Oregon participated in the eugenics movement, sterilizing more than 2,600 people between 1923 and 1983. Hundreds of lobotomies were performed in the OSH surgical center. Thousands of electroshock, insulin shock, and Metrazol shock treatments were administered to patients before psychoactive drugs were developed.

Dr. Dean Brooks brought significant changes to OSH when he became superintendent in 1955. That same year, OSH instituted a food rationing system, which guaranteed a varied and balanced meal menu for all patients year-round. The 50 Building was completed, adding 676 new beds to the facility. Unfortunately, the top floor was not occupied until after 1992 because of plumbing and other construction problems. The last year that OSH provided maintenance support for the superintendent and staff physicians was 1957, at which time OSH also transferred all its laundry equipment and contracted with the Oregon State Penitentiary to clean all hospital linens and laundry.

By 1958, the hospital population had reached its maximum, at 3,474. According to hospital reports, 27 percent of the patients were being treated with tranquilizing drugs, lessening the need for straightjackets and other restraints. It also facilitated the release and rehabilitation of hundreds of chronic patients who could never have been released previously. OSH also established a training program for psychiatric nurses and a two-year residency program in psychiatry for physicians. Superintendent Brooks instituted a unique program in 1965, when 30 teenagers between the ages of 12 and 18 became the first junior volunteers. The students worked full-time during the summer months.

The Psychiatric Security Program for forensic patients was founded in 1966, as it became apparent that a larger portion of the patient population was coming from the criminal court system. Dr. Brooks's approval and support of moviemakers filming *One Flew over the Cuckoo's Nest* inside the hospital helped create an atmosphere of change and opportunity. By 1975, the patient population had been reduced to below 1,000, and those remaining were primarily forensic patients. In 2004, a group of legislators helped publicize the fact that cremains of over 3,500 patients were stored in a shed near the mortuary.

On Wednesday, December 18, 1942, patients at OSH were fed a dinner of scrambled eggs. Within 15 minutes, they began complaining of nausea, cramps, vomiting blood, and the inability to stand because of violent leg cramps and paralysis. The first death occurred an hour later. By midnight, 32 patients had died. By 4:00 a.m., 40 had died. Eventually, a total of 38 men and six women from four wards died. (Courtesy of ORE, December 20, 1942.)

Investigation revealed that the kitchen had only three full-time employees cooking for more than 3,000 patients and staff. The head cook, Mary O'Hara (left), and her assistant, A.B. McKillop (right), relied on a patient who had mistakenly retrieved five pounds of roach poison instead of powdered milk, making 467 patients ill. One pound of the poison could kill 2,000 people. (Courtesy of ORE, December 20, 1942.)

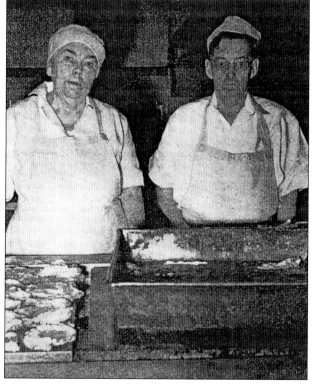

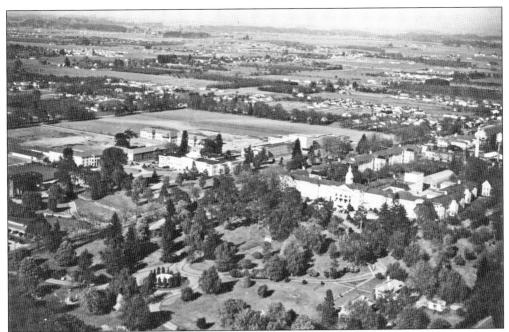

This overhead photograph from about 1950 shows preparations for construction of the 50 Building. As of 1942, OSH had 2,728 patients in buildings meant to house 2,000. A day attendant was responsible for 16 patients, and at night, a single worker was responsible for 150 patients. There were only eight physicians and one dentist. Oregon was spending 45¢ a day per patient. (Courtesy of SPL.)

On March 30, 1944, two patients were killed while digging a ditch from the hospital to the Salem sewer system. No shoring had been used from the manhole on Center Street until the ditch had passed over one of the underground tunnels. As late as 1948, sewage from the hospital and from the city of Salem was being dumped directly into the Willamette River. (Courtesy of SPL.)

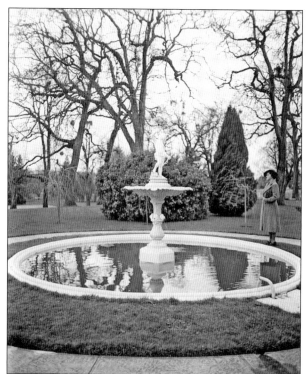

By 1953, physicians were admitting more than 1,000 patients a year, or approximately 3 or 4 per day. Nearly a third of the admissions were elderly patients suffering from Alzheimer's disease. Another third were schizophrenic patients suffering in a cycle of admissions and releases. The last third were primarily forensic patients sent there by the court system. There were only 16 full-time physicians for more than 3,000 patients. (Courtesy of SPL.)

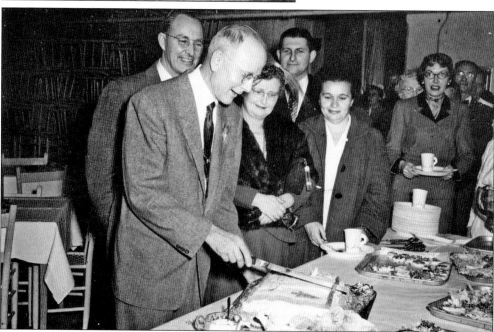

Dr. Charles Bates was superintendent from 1948 to 1954. In an interview just before he retired, he said, "Insulin coma therapy was the biggest advance in psychiatric treatment during [his] 42-year career at the institution." By 1950, a total of 9,309 insulin treatments had been administered in the previous two years. By 1954, that had increased to 23,316. The use of insulin decreased rapidly after that. (Courtesy of SPL.)

Dr. Dean Brooks was the OSH superintendent from 1955 to 1981. Dr. Joseph Treleaven stated that Dr. Brooks created "a climate of change at the hospital, one of participation," by establishing committees and a sense of collaboration between the administration and the employees. (Courtesy of SPL.)

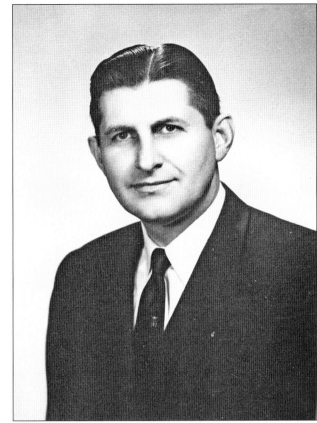

Building 50 was put into service in 1955 with 680 beds designed to serve the large geriatric population living in the hospital at that time. It was designed by Hollis Johnson of Portland and cost $1.5 million to build. (Courtesy of NRHP.)

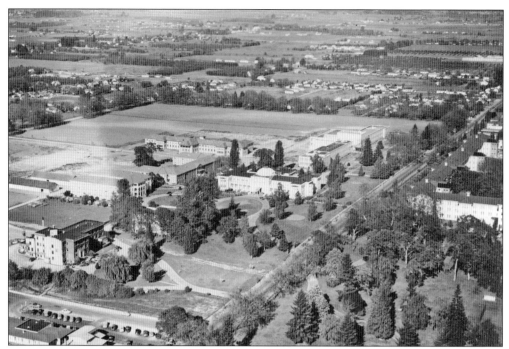
Looking to the east onto the OSH campus, this overhead photograph shows Center Street running east and west. At the bottom is the old Salem Hospital. To the left of the Dome Building are Building 33, built in 1947, and Building 40, built in 1948. Directly above and east of the Dome Building was Building 35, also built in 1948. (Courtesy of SPL.)

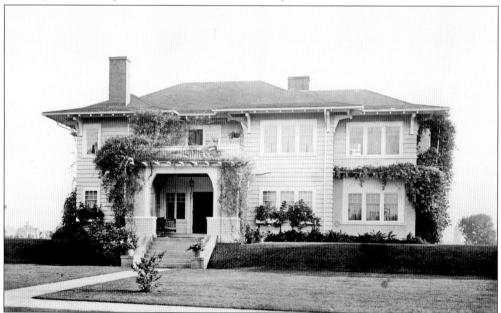
This is one of the two physician's houses built in 1909 at a cost of $10,000. An additional $500 was allocated in the budget to help supply and furnish the homes. Between 1909 and 1958, there were 28 cottages built on campus specifically to house OSH employees. Most were smaller than this. Today, they are used as offices, storage, and transitional housing for patients. (Courtesy of OSA.)

In 1954, Dr. Charles E. Bates, the superintendent from 1948 to 1954, reported that there were 3,250 patients and 856 employees at OSH. Nearly 533 of the employees were hospital or ward attendants. During the previous two years, a total of 23,316 shock therapy treatments, 19,609 hydrotherapies, and 13,825 physiotherapies were administered. An additional 1,590 insulin injections were given to geriatric patients. Superintendent Bates also reported that 18 patients had received lobotomies. By 1954, there were 17 psychiatrists and physicians, two dentists, and three consulting physicians employed at the hospital. In contrast, in 1948, there had only been 6,854 electroshock and 323 Metrazol treatments. (Both, courtesy of OSA.)

Shock Therapy

Insulin:
- Treatments — 9,918
- Comas — 7,043
- Sub Coma Insulin — 13
- Sedation Insulin — 129
- Pre-Comas — 247
- Prolonged Comas — 10
- Grand Mal Seizures — 12
- Convulsive Seizures — 163
- Accidents — 1
- A.C.T.I.D. Insulin given — 5,780

Convulsive Shock:
- Electric Shock — 22,387
- Electronarcosis — 159
- Metrazol — 2,471
- Metrazol/I.C.T. — 24
- Carbon Dioxide (CO_2) — 877
- Combined Reiter — 35
- Brief Intensive Electric Shock — 73
- Hypnosis — 37
- Desoxyn Interviews — 28
- Desoxyn/Sodium Amytal Interview — 2
- Sodium Pentothol Interview — 10
- Sodium Amytal Interview — 20

Hydrotherapy

- Whirlpool — 3,054
- Sitz Baths — 1,628
- Continuous Tubs — 10,270
- Wet Sheet Packs — 2,846
- Salt Glows — 1,334
- Hydrotonic — 477

Total — 19,609

Physiotherapy

- Ultra Violet Ray — 9,431
- Infra Red — 629
- Diathermy — 2,449
- Massages — 516
- Passive Exercises — 540
- Showers — 229
- Breathing — 18
- Mag. Sulf. Foot Bath — 13

Total — 13,825

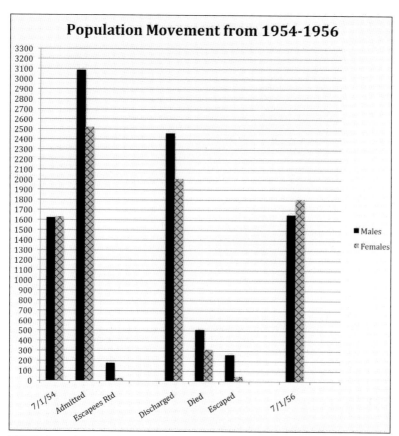

The development and introduction of tranquilizers and antipsychotic drugs helped reduce the number of patients at OSH from nearly 3,600 in 1958 to 650 in 1980. In addition, 324 elderly patients were transferred on June 30, 1963, to public welfare-sponsored nursing homes or homes for the aged. This program continued until only the elderly people with severe mental illnesses remained at the hospital. (Analysis by the author.)

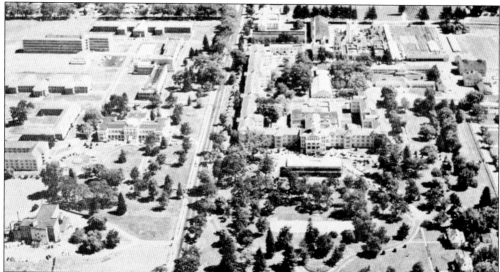

After the patient population peaked in 1958, with 3,545 patients and a staff of 1,000, it began a steady decline, due primarily to the new drugs that were available. Federal funding increased for the elderly, and Alcoholics Anonymous helped move a large number of patients out of the hospital. By 1961, wards containing a total of 586 beds had been closed, making 1,107 beds for men and 1,194 beds for women available in the hospital. (Courtesy of OSH.)

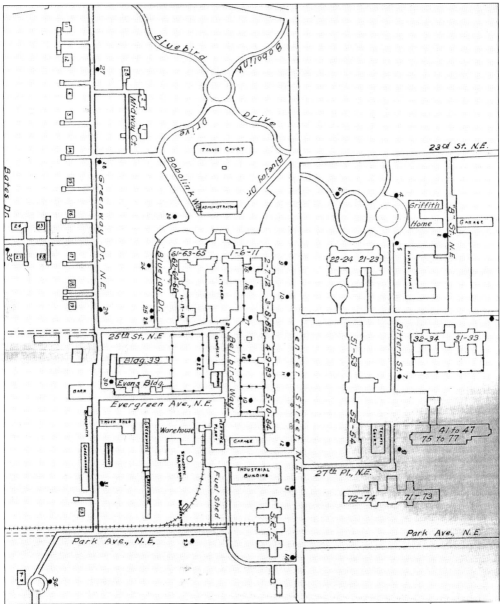

This map of the OSH campus was published in 1966 and corresponds with the overhead photograph on the previous page. It shows the completed campus before reconstruction began in 2008. For example, the first floor was Ward 1, the second floor was Ward 6, and the third floor was Ward 11. As of June 30, 1966, there were 44 wards in operation, housing 1,589 patients. The hospital was licensed to serve 2,388 people. Three of the wards were remodeled to accommodate the new Psychiatric Security Program, with three levels of security, in Wards 82, 83, and 84. This program cared for patients transferred from the various corrections facilities, patients sent by court order for psychiatric evaluation, patients labeled sexually dangerous, and patients from within the hospital who required secure housing. At the center top was the Salem Rehabilitation Facility, which opened in March 1966. This was operated in conjunction with OSH and was one of the many buildings razed to make room for the new hospital in 2010. (Courtesy of OSA.)

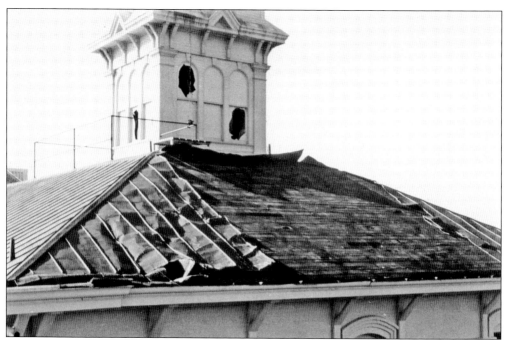

On October 12, 1962, the Columbus Day storm struck Oregon. The storm crossed the California-Oregon border at noon and blew up the Willamette Valley from the south at about 40 miles per hour, creating a swath of destruction and reaching Salem in the mid-afternoon. Wind gusts reached 90 miles per hour, and sustained winds reached 70 miles per hour. There was $4 million in damage to buildings and private property in Salem. (Courtesy of OSA.)

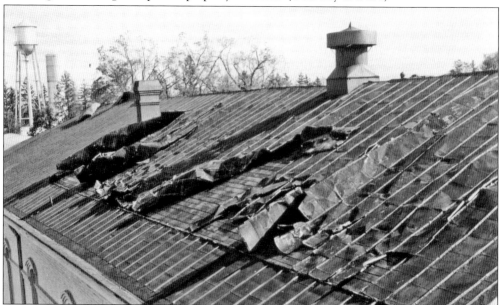

The Columbus Day storm was classified as an extra-tropical storm system. It was the remains of Typhoon Freda, which had formed out in the Pacific Ocean and was the equivalent to a category-four hurricane. The entire northwest power grid had to be rebuilt afterwards. It is classified as the worst storm to hit the West Coast in the 20th century. (Courtesy of OSA.)

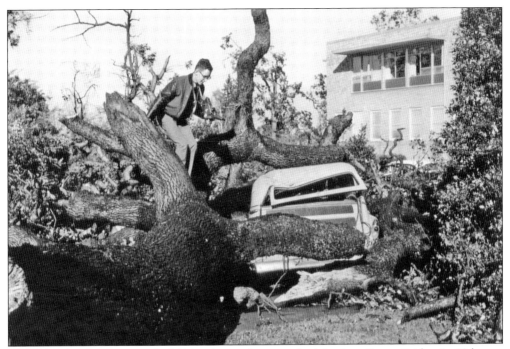

In Portland, wind gusts reached 116 miles per hour on the Morrison Street Bridge. In 12 hours, more than 11 billion board feet of timber was blown down in northern California, Oregon, and Washington. Nearly $200 million of damage occurred in Oregon alone. A total of 46 fatalities were attributed to the storm, as were hundreds of injuries. (Courtesy of OSA.)

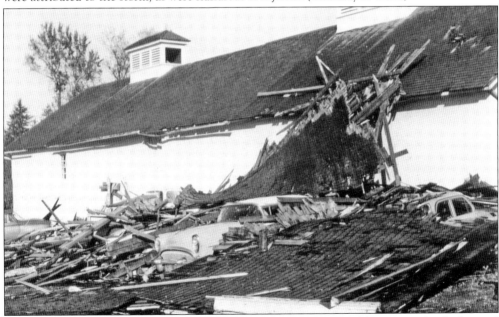

It took months to repair all the buildings at OSH and remove all the debris. Trees that had graced the campus for nearly 100 years were damaged. For weeks, gas-powered generators provided the necessary power to cook the food and heat the buildings. Employees made heroic efforts to reach the hospital, knowing they were needed to care for the nearly 3,000 patients. (Courtesy of OSA.)

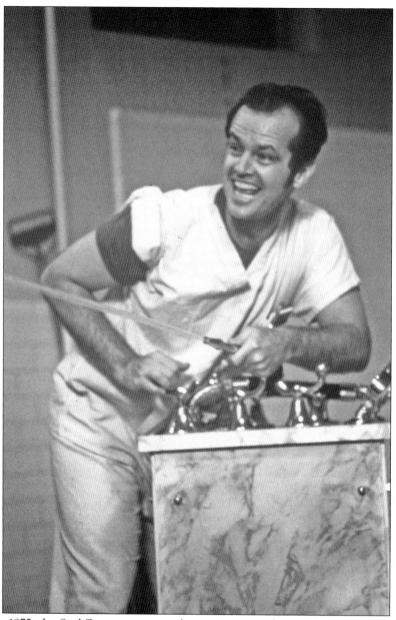

In January 1975, the Saul Zaentz movie production company began filming *One Flew over the Cuckoo's Nest* inside the J Building at OSH. The book was written by Oregonian Ken Kesey (1935–2001) and published in 1962. Filming took 11 weeks, from January through March. More than 90 patients and many employees participated in the production. Michael Douglas and Saul Zaentz were producers, and Milos Forman was the director. The movie won five Academy Awards in 1976. It was the first film in 41 years to sweep the major categories of best picture, best director, best actor, best actress, and best screenplay. Jack Nicholson won best actor for playing the character Randall P. McMurphy. Louise Fletcher played Nurse Ratched and became a cinematic icon, ranking fifth in the American Film Institute's list of the top 100 movie villains of all time. (Courtesy of the Saul Zaentz Company, *One Flew over the Cuckoo's Nest*, all rights reserved, copyright 1975.)

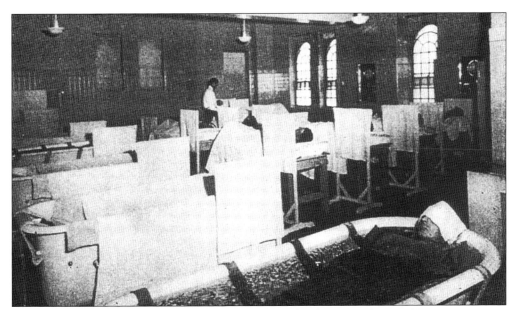

Hydrotherapy became part of the standard treatment plan by 1936, when 2,760 treatments were administered in a single year. Continuous bath therapy consisted of a dozen patients at a time being confined to tubs of water for extended hours. The temperature was maintained at 98.6 degrees by central control panels. There were also foot tubs and heat cabinets. (Courtesy of OSH.)

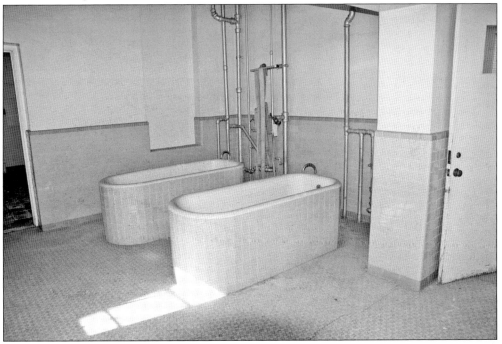

Various kinds of water therapy were used in 1950, when 13,156 treatments were administered. Water therapies included needle sprays with showers, wet sheet packs, whirlpool baths, saltwater baths, sitz baths, cold compresses, hot compresses, medicinal footbaths, arm baths, prolonged baths on the wards, fomentations (a substance used as a warm moist medicinal compress or poultice), and hypodermoclysis (used to rehydrate elderly patients.) (Courtesy of NRHP.)

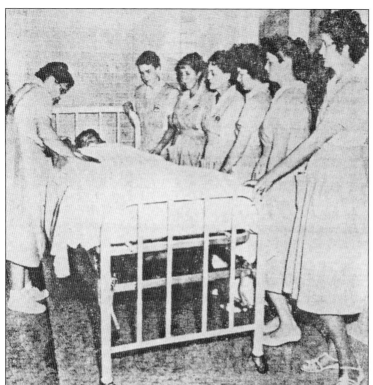

A new nurse's dormitory housing 100 nurses was constructed in 1948 at a cost of $381,232. The building provided rooms for students and registered nurses. It had kitchens and recreation areas on each floor. Matrons supervised the student section. In October 1964, a new in-service training program for psychiatric aides was implemented. (Courtesy of OSA.)

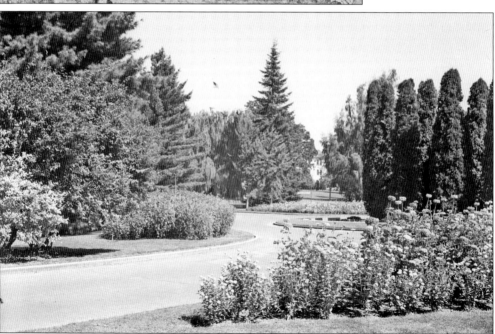

Several driveways and entrances from Center Street wound gently around the OSH grounds, creating a pleasant, parklike atmosphere as patients and employees entered the campus. Many flowering bushes and a large variety of trees created an aura of calm surrounding the many buildings in the 1950s. (Courtesy of SPL.)

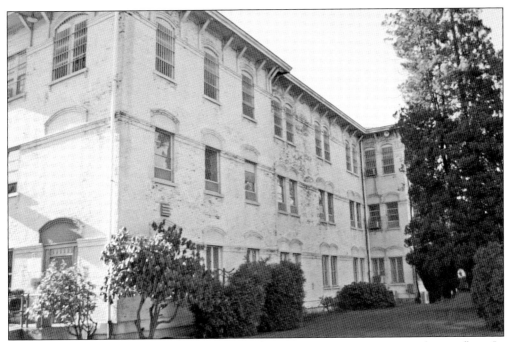

This is the eastern end of the J Building, with the maximum-security unit on the top floor. In the 1960s, there were several suicides and attempted suicides. This was a problem throughout OSH history, as severely depressed patients were committed to the hospital. Patients usually committed suicide by hanging themselves with clothing or strips of bedsheets, or by jumping out of the third-story windows. (Photograph by Laurie L. Burke.)

Building 43 is seen here in 2008. From this time forward, the majority of commitments were forensic patients. These patients were sent through the criminal court system and were either in the hospital to be evaluated before a trial or were there after being found "guilty except for insanity." (Courtesy of UofO.)

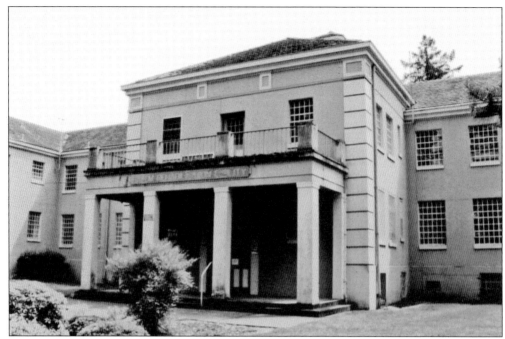

The Salem Rehabilitation Facility (Building 49) was opened in March 1966. It was funded by a federal grant in a joint program between OSH and the Division of Vocational Rehabilitation to evaluate and train the long-stay hospital patients in work relationships. The patients received nominal pay for participating in projects such as box making and candle wrapping. (Courtesy of the NRHP.)

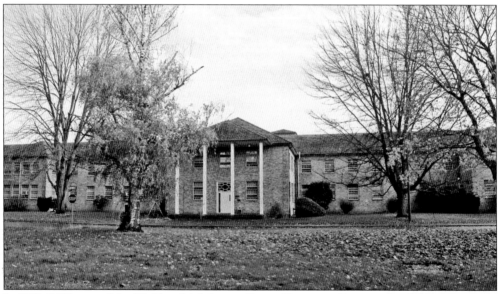

In 1976, OSH opened the Child and Adolescent Secure Treatment Program for children ages eight to 18. It included a school, a recreation center, and therapeutic group activities. It was housed in Building 40, which was built in 1948. The youngest 20 children lived on the first floor, and the oldest 20 lived on the top floor. The program was dismantled on March 1, 2005. (Photograph by Laurie L. Burke.)

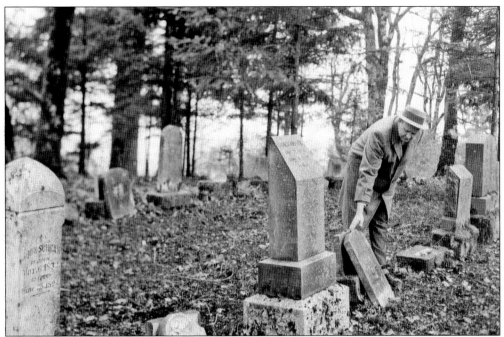

In 1959, a total of 28 headstones, with death dates ranging from 1884 to 1909, were discovered in trees to the southeast of the hospital on land that used to belong to the Cottage Farm. An investigation revealed they were from the original asylum cemetery. Previously, 1,539 bodies had been cremated in 1913, and the unclaimed cremains were put in copper canisters and stored in the basement of Building 40. (Courtesy of SPL.)

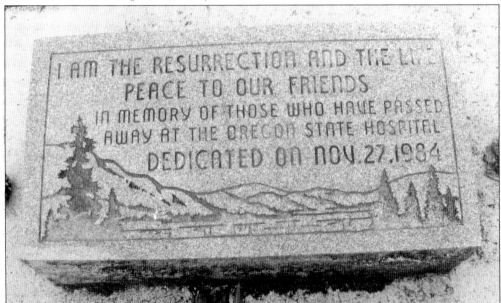

In 1976, the cremains were removed from their storage facility in the basement of Building 40 and placed in the vaults of a columbarium. There were 5,118 cans packed into 12 underground storage chambers in what used to be the fishpond, on the southwest corner of the hospital property. In 1984, a small headstone for the dead was placed at Memorial Circle. (Courtesy of OSH.)

With many canisters, the only identification was the number embedded on their lids. The consecutive numbers began with 01 and continued to 5,118. The majority of the cremains contained the ashes of patients who had been cremated after 1913. The cremains were inventoried, with the ultimate goal of uniting them with family members. (Courtesy of OSH.)

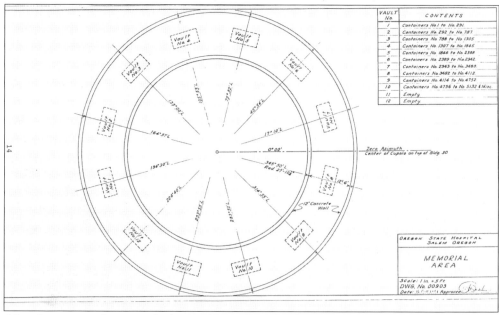

After discovering that water had seeped into the columbarium and corroded the containers in 2000, authorities decided to move the cremains to shelves in Building 75. By 2011, the publicity had reunited more than 1,600 canisters with family members, leaving the unclaimed remains of 3,476 people. Chemical corrosion had caused many of the cans to turn green, and others had fused together, making individual identification difficult. (Courtesy of OSH.)

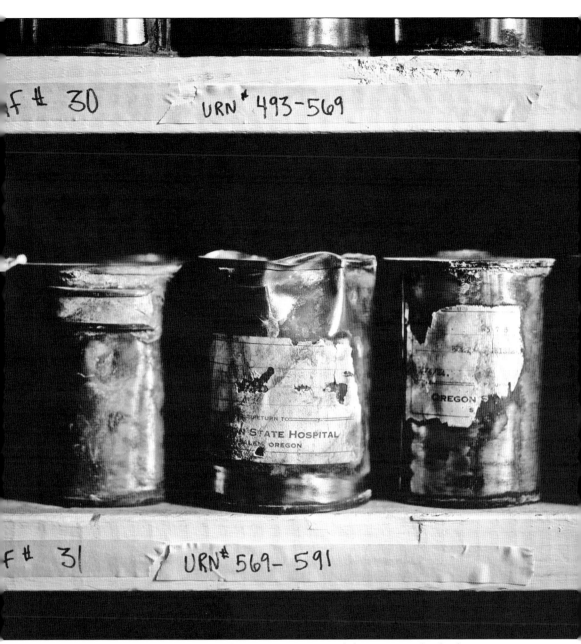

On November 1, 2004, a group of legislators on a tour viewed the cremains for the first time since 2000. They were the unclaimed bodies of patients who died between 1913 and 1971 at Columbia Park Hospital, Oregon State Penitentiary, Dammasch State Hospital, Fairview Training Center, Oregon State Hospital, and the Oregon State Tuberculosis Hospital. In 2005, photographer David Maisel labeled the room "the Library of Dust." The paper labels with the names of the dead were mostly gone, and each canister had acquired its own intense color. It took two years for OSH employees to research the names. The names of the 3,476 persons were posted on the Internet on January 28, 2011. Today, a building has been moved and refurbished to hold the cremains and allow visitors to honor the dead. (Photograph by Rob Finch, courtesy of ORE.)

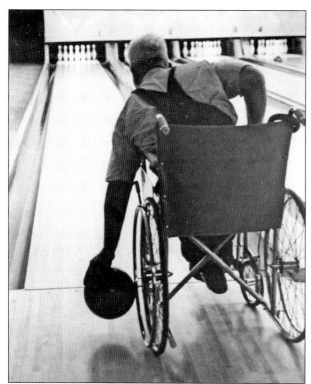

By 1960, many of the wards had ping-pong tables, and everyone had playing cards available for use. The hospital librarian visited each ward weekly, carting games, books, and jigsaw puzzles from place to place. The library had more than 2,200 volumes of fiction and 500 volumes of nonfiction. All wards had radios and most had televisions. Patients also wrote articles for the monthly newsletter, the *Lamplighter*. (Courtesy of OSA.)

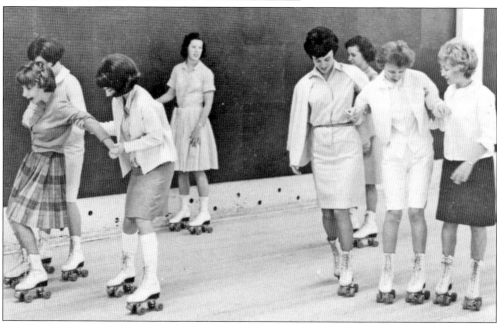

In the 1970s, patients were allowed various activities as part of their therapy. Besides roller-skating, patients participated in volleyball, softball, ping-pong, weekly dances, and movies. Coed dances allowed teenagers to have the same experiences they might have had outside the hospital. A successful program of camping and hiking trips was also offered to selected patients. (Courtesy of OSA.)

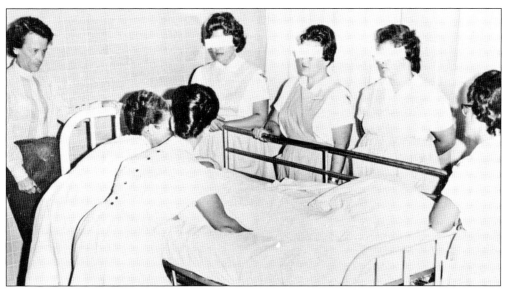

A school for student nurses was initiated at OSH in 1943. Within the first six years, 1,147 nurses completed the three-month training course. Approximately 75 nurses per term were accepted into the psychiatric nursing school. Also in 1949, OSH began operating a 21-week training course for attendants based on principles laid down by the American Psychiatric Association. (Courtesy of OSA.)

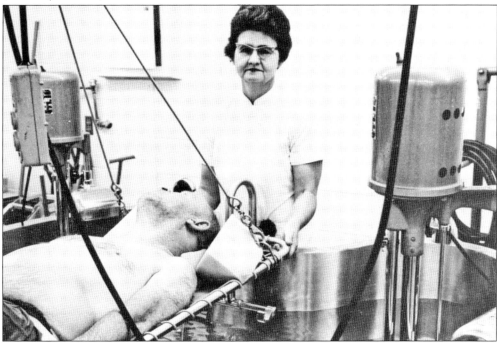

Attendants worked 12-hour days until 1953, when OSH instituted three 8-hour shifts per day. Employees were encouraged and retrained to provide a more respectful environment for their patients. This "humanization" program gave patients more freedom, better food, and more privacy. It focused attention on what was best for the individual instead of what was easiest for the institution. (Courtesy of OSA.)

This photograph of OSH was taken in April 1990, when it housed sex offenders. It shows the bars in the windows on the north corner of the J Building. It was remodeled in 1963 to house sex offenders after the law was changed, requiring OSH to create a separate treatment area. Within five years, 70 patients had been admitted for evaluation. Of those, 50 were admitted for treatment, and 35 were paroled or discharged. (Courtesy of SJ.)

Supt. Stan Mazur-Hart installed chain-link fencing and razor wire around the recreational areas used by the high-security wards. The Forensic Psychiatric Program housed the most dangerous patients in the top floor of this building in 2008. Approximately 75 percent of all patients in the hospital were sent by the criminal court system and were supervised by the Psychiatric Security Review Board. (Photograph by Laurie L. Burke.)

This photograph shows Wards 63 and 64, inside the J Building, after 40 percent of it was deemed unusable and left to rot. In 1960, visiting hours at OSH were from 10:00 a.m. to 11:30 a.m. and 2:00 p.m. to 4:00 p.m. daily. Patients were allowed one stamp a week and stationery. A beauty shop and a barbershop were available. Patients did not have access to telephones and could not make or receive calls. (Courtesy of NRHP.)

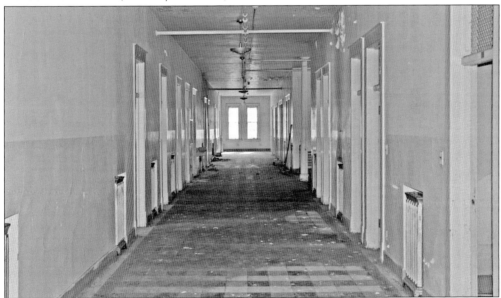

Supt. Dean Brooks involved patients in hospital policy and treatment programs through the creation of a Superintendent's Committee of Patients, representing each ward in the hospital. He strengthened the existing patient government groups and patient representation on the hospital's Central Policy Committee. He also revised the admissions process to ensure patients were referred to the most appropriate resource within the hospital or outside of it. (Courtesy of NRHP.)

The J Building is the oldest intact public building in Salem and is the best example of a Thomas Kirkbride–inspired hospital surviving on the West Coast. OSH is a fine model of a High Victorian Italianate-style building, with cupolas on the central entrance structure and connecting wards. By 2008, deterioration had made much of it uninhabitable. (Photograph by Laurie L. Burke.)

On December 2, 2002, Gov. John Kitzhaber issued a public apology to the nearly 2,600 Oregonians sterilized in the last 60 years. Following the eugenics policy first passed into law in 1917, "the state forcibly sterilized children, as well as people with mental disorders, disabilities, epilepsy, and criminal records. Nearly all of them were vulnerable, helpless citizens entrusted to the care of the state by their families or the courts." (Courtesy of the office of Gov. John Kitzhaber.)

Five

TUNNEL THERAPY

According to the 1883 architect's report, "The basement under the ward buildings being 7'4" in the clear, is constructed for the purpose of providing room for the railways intended to convey food and other necessities from the kitchen to the dumb-waiters for the various dining rooms on the floors above also for the furnace and wood rooms. The basement of the kitchen building is 10'4" in height and is located directly in the rear of the main or office building . . . A car track runs from the kitchen to the center of the building connecting with a turn-table enabling the car to run either to the right or left as desired."

In 1957, Dr. William W. Thompson, from OSH, was testifying in Portland to a group investigating psychiatric hospital practices in Oregon. Inadvertently, he used the phrase "tunnel therapy" in an attempt to illustrate how difficult it was to balance the need for security and the need for freedom to treat some psychiatric patients. After a flurry of negative publicity, the Oregon State Board of Control convened a special session to determine if patients or employees were participating in any kind of sexual activities inside the tunnels under OSH. Members of the panel included Mark Hatfield, secretary of state; Sig Unander, state treasurer; and William C. Ryan, board secretary.

The panel interviewed Supt. Dean Brooks, who escorted news reporters and photographers through the tunnels. "There," he said, pointing at the cold cement floor as the cameras clicked away, "Do you imagine anyone wants to make love here?" No proof of any kind was discovered, however, the term lingered on in OSH folklore. As wings were added to the main building and new structures were erected on campus, the tunnel system was expanded. Today, the tunnels no longer cross under Center Street, and they only connect a few of the buildings on the north side of Center Street.

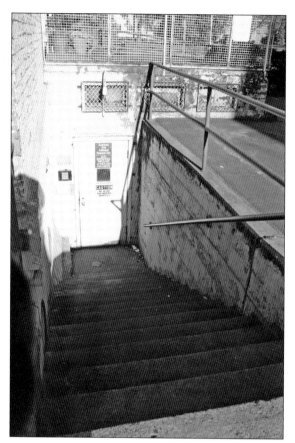

This entrance, under the J Building, is only one of the many entrances leading into the nearly two miles of tunnels under OSH. Some sources stated that there were more than three miles of tunnels, but OSH authorities discount that. Most people entered and exited the tunnels from inside the various buildings. (Photograph by Laurie L. Burke.)

The tunnel railways were extended aboveground in the early 1900s from under the J Building to connect the barns, farm storage buildings, and service buildings. Between 1892 and 1894, a new switch and approximately 855 feet of rails were constructed when the infirmary was built. (Courtesy of NRHP.)

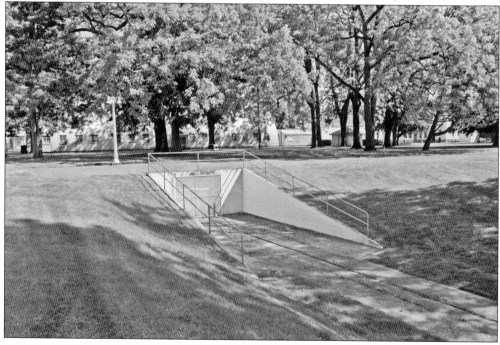

The first tunnel under the J Building was built in 1883 to facilitate a narrow-gauge railroad. It was used to haul fuel to the boilers, providing heat to the building, as well as to bring food from the central kitchen to the various dining rooms in the wards. It was a common design for large institutions at that time. (Photograph by Laurie L. Burke.)

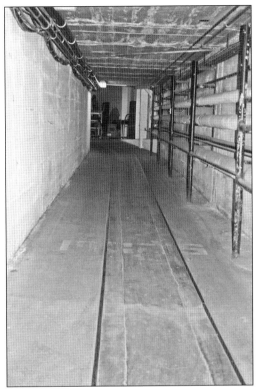

This handmade wooden handle on a door under the J Building represents the attention to detail and the quality of the work performed when the building was constructed in 1883. Wooden beams holding up the building still showed the hand-hewn ax marks, defining the antiquity of the facility. (Photograph by Laurie L. Burke.)

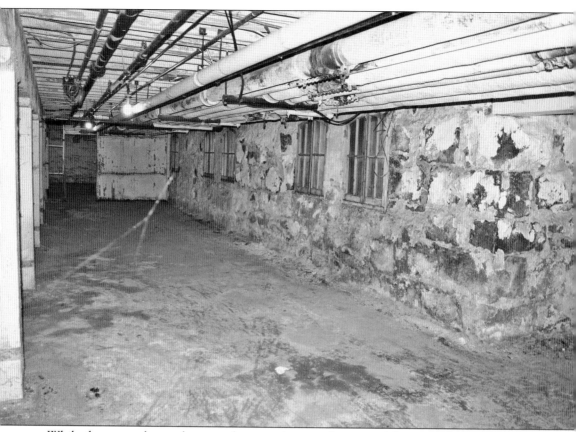

While there was plenty of room to house patients under parts of the original northern part of the J Building, also referred to as Buildings 42 and 43, there was only dirt flooring. Building 43, constructed in 1910, had only wooden supports holding up the three-story structure and a dirt foundation. Building 42, the original part of the building, was also rumored to have housed patients in its dirt-floor basement. (Photograph by Laurie L. Burke.)

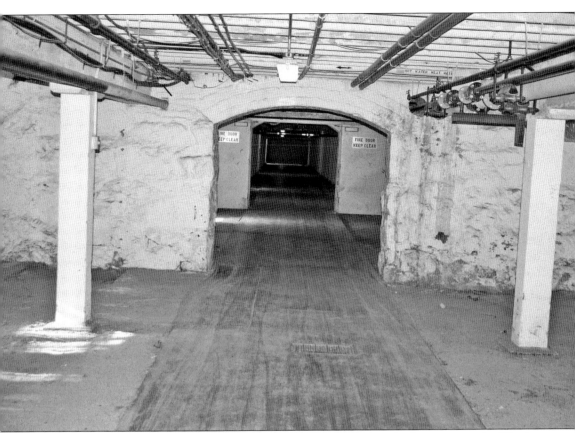

A 1955 newspaper article mentioned that patients were housed in the basement under Ward 41, the front portion of the north section of the J Building, before being moved to the new 50 Building. During the same time period, a constant stream of men and materials passed through the tunnels as construction on the 50 Building came to its climax. When the hospital population declined, the rail lines under Buildings 30, 31, 41, 42, 43, 47, and 48 were removed. The floors were repaved to accommodate the more versatile carts, equipped with rubber tires. According to the *Statesman Journal*, in a hospital tour sponsored by OSH in 2008, participants were told that during "the hospital's peak population, excess patients had to be housed in the hospital's tunnel system." (Photograph by Laurie L. Burke.)

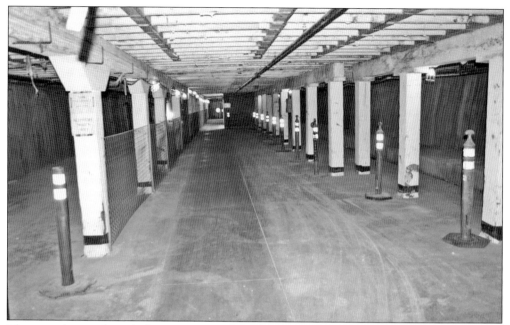

The tunnels served as a linking system used for the practical purpose of connecting a variety of infrastructure systems, such as water, power, sewer, heat, and communication. Until reconstruction began in 2008, they also served as a conduit for food prepared in the central kitchen and for the delivery of laundry, furniture, and other necessary supplies. Repair efforts in 2009 are seen here. (Photograph by Laurie L. Burke.)

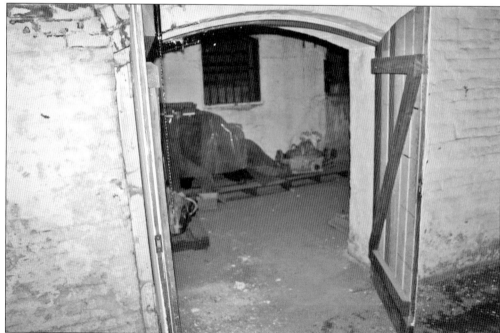

In 1892, the basement of the J Building included a vegetable storeroom, a bread bakery, general storerooms, a track for cars running from the center to the dumbwaiters of the wards, and the furnaces for the hot water and steam heating. (Photograph by Laurie L. Burke.)

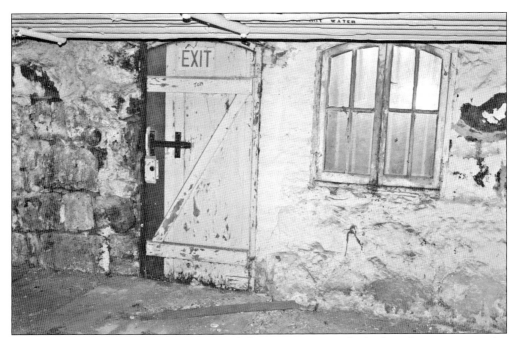

A report dated January 16, 1953, requested that OSH remove the beds and mattresses in the basement under Ward 36, on the first floor of the original north wing of the J Building. The fire inspectors recommended that the area be enclosed with fire-resistant material, probably asbestos, and a self-closing fire door. This photograph shows the rubble foundation. (Photograph by Laurie L. Burke.)

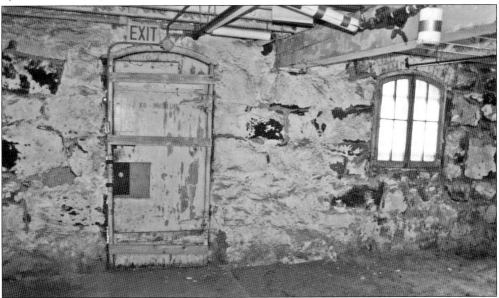

In 1964, space in the tunnel under the south wing of the J Building was used by volunteer services for its Toggery Shop, where patients could receive clothing and other donated items free of charge. More than 15,896 articles were given to 1,817 patients in the first year. However, the space had no dressing room, no electrical outlets, no running water, and no bathrooms. It was eventually relocated to a better location. (Photograph by Laurie L. Burke.)

As of December 31, 2008, all the rails had been removed and cemented over except for the basement tunnel running from Building 48 to Building 49 and the east-west tunnel running between Building 46 and Building 59. The tunnels passed under Center Street in two places. (Photograph by Laurie L. Burke.)

At about 10:00 a.m. on a 1959 morning, a male patient working on the hospital grounds with about 100 other men escaped via an unlocked tunnel door. Racing through the tunnels, he exited near Thompson Avenue Northeast, where he was caught about 40 minutes later molesting a three-year-old girl. He had been in the hospital for 20 years and was a patient in the medium-security ward. (Courtesy of NRHP.)

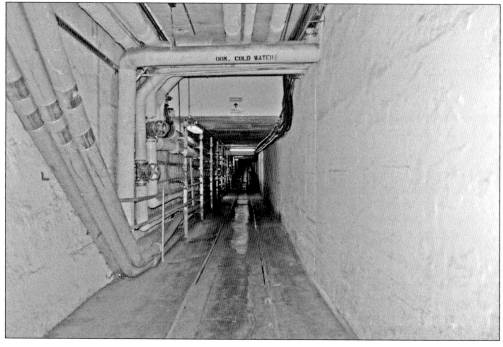

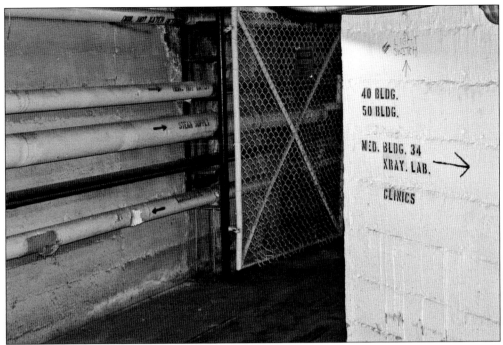

The swimming pool, featured in the movie *One Flew over the Cuckoo's Nest*, was in the basement of Building 35. The building was erected in 1948 at a cost of $1,624,415. In the 1960s, the building served as the home for the Child and Adolescent Treatment Center. Tunnels were connected to it, just as they were to all new buildings. (Photograph by Laurie L. Burke.)

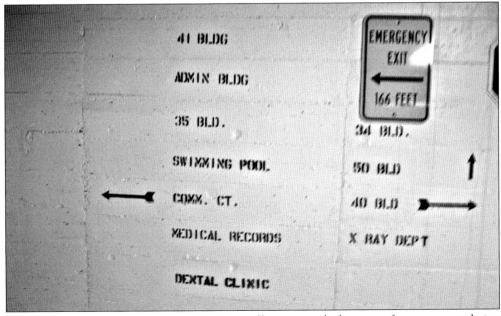

Signs were stenciled at every intersection in an effort to provide directions for anyone wandering the tunnels. This intersection has an arrow pointing to the swimming pool. However, because of faulty construction, the pool was locked up shortly after the movie was filmed and never used again. (Photograph by Laurie L. Burke.)

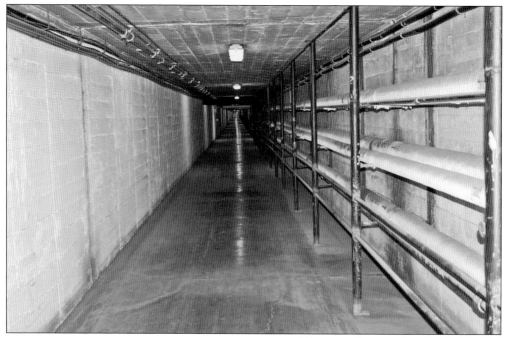

The tunnels crossed under Center Street in two places. A north-south extension connected the Dome Building and the J Building at Building 42. A second tunnel came from the eastern portion of the campus under Twenty-seventh Place and connected to the end of the J Building at a 45-degree angle. (Courtesy of NRHP.)

In an effort to provide as much natural light as possible, glass tiles were cemented in the ceiling of the tunnels as they crossed under the sidewalks lining Center Street. The thick tiles were strengthened with manganese, which when exposed to sunlight over time became a deep purple color. Inside the tunnel, it created a glittering violet twilight extending 10 to 15 feet in both directions. (Photograph by Laurie L. Burke.)

In 2006, OSH was fined $10,200 for not warning a contractor that the material wrapping the pipes they were repairing contained asbestos. Along with lead paint, asbestos was a serious problem during the demolition and reconstruction of the hospital, as expensive precautions were required before the nearly 52,000 dump trucks of material could be hauled off. (Photograph by Laurie L. Burke.)

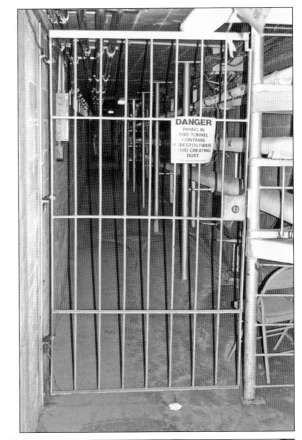

In 1922, Supt. R.E. Lee Steiner used $1,500 to build a much-needed room for file storage and supplies (below) in the basement tunnel under the main section of the J Building. It was abandoned after a new administration building was erected in 1950. (Photograph by Laurie L. Burke.)

Pipes lining the tunnels carried everything from hot and cold water to computer wires. Besides water, the pipes carried telephone lines, sewage, and heat throughout the campus. (Photograph by Laurie L. Burke.)

Food, prepared in the central kitchen behind the J Building, was transported through the tunnels in specially constructed containers. After the narrow-gauge railway was discarded, the carts were refitted with large balloon tires, making them easier to move. Eventually, electric carts were purchased, and multiple carts could be attached and moved from place to place. (Photograph by Laurie L. Burke.)

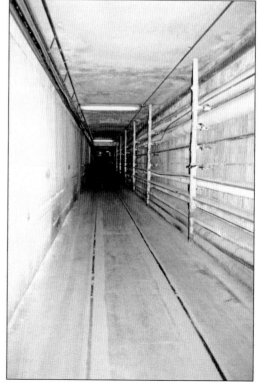

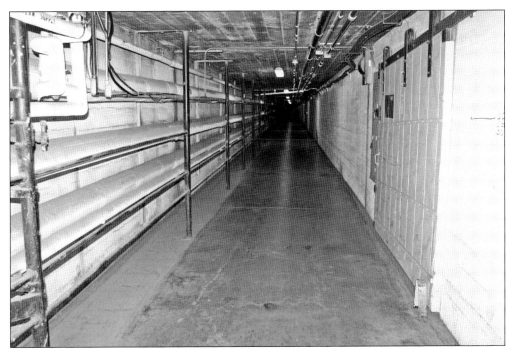

During the years OSH had a children's treatment unit, the patients and their counselors liked to go roller-skating in the tunnels when it was raining outdoors. On December 10, 1966, the *Oregon Journal* reported: "Twenty skaters at a time can fly through the long fantastic concrete tunnels that run for miles underneath the hospital." The squealing and laughter would echo through the tunnels loud enough to warn any unwary pedestrian to run for cover. (Photograph by Laurie L. Burke.)

In July 1990, a dangerous forensic patient used an elevator to escape into the tunnels from his medium-security ward in Building 50. By following the signs stenciled on the tunnel walls, he made his way outside and left the hospital grounds. He was finally recaptured about six months later in Arizona and returned to OSH. (Photograph by Laurie L. Burke.)

The original containers carrying laundry, supplies, and food from place to place under OSH were made of bamboo. Around 1950, the train was replaced with these more versatile electric carts, which could be attached to a variety of containers. Drivers were required to beep as they approached blind corners to warn unwary pedestrians and bicyclists, creating eerie echoes off the cement walls. (Photograph by Laurie L. Burke.)

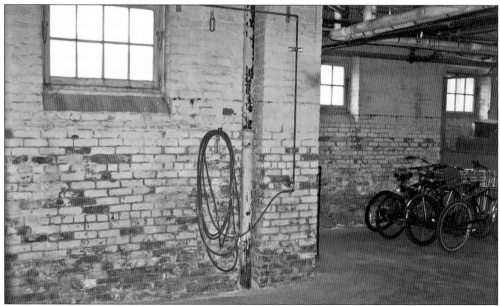

The bicycles were freely used by whoever needed them and then left inside for the next person. Nick Maselli, a current hospital employee, recalled riding his bike inside the tunnels as a child to join his mother, who worked as a physical therapist at OSH. Sometimes, the security guards chased him, more in fun than anything else. He remembered OSH as a friendly and safe community. (Photograph by Laurie L. Burke.)

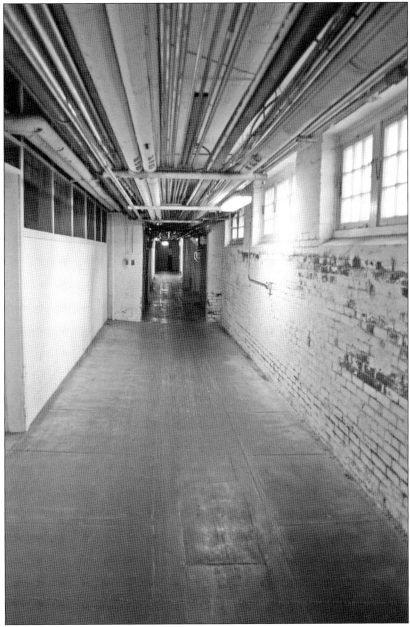

In 1931, a new industrial room was installed and equipped in the east basement of the J Building. This allowed the hospital to provide employment and activities to the patients from the criminally insane wards and to certain patients who needed to be kept under strict supervision. In 1938, the basement areas under Wards 39 and 40 were remodeled at a cost of $10,000. In 1954, there were 125 employees living in a basement ward off the tunnels. Patients were escorted through the tunnels in privacy to various buildings for tests, services, and therapy. Food was transported in insulated food carts, and laundry was transported back and forth from the wards to the laundry facility. This photograph was taken under Building 42. The narrow-gauge railroad was still used as late as 1965 to transport people, supplies, and food all over the campus. After the railway system was dismantled, the carts were refitted with pneumatic tires. (Photograph by Laurie L. Burke.)

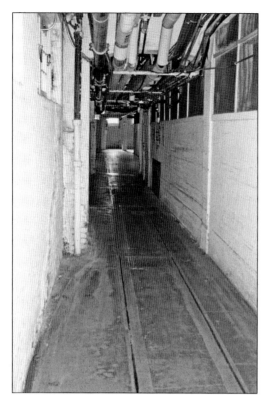

The original narrow-gauge railway used small, flat, wheeled railroad carts throughout the hospital tunnels. Depending on the types of products needing to be transported from place to place, a variety of carts were designed with different kinds of containers. Reports called for the construction of laundry boxes with lids, kitchen railcars, and railroad cars for wood. (Photograph by Laurie L. Burke.)

It is easy to believe that the tunnels could go on for miles and miles as one walks aimlessly through them. They seem to echo with 100 years of human pain, misery, and heartache. (Photograph by Laurie L. Burke.)

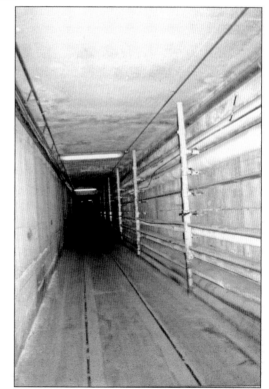

Six

REBUILDING THE HOSPITAL

A major change occurred in 2004, when a task force set up by Gov. Ted Kulongoski recommended that OSH "provide secure housing for individuals who pose a danger to society or themselves." Eventually, authorities decided to renovate the Salem facility and build a secondary facility in Junction City, Oregon. The Salem building would cost about $280 million, and the Junction City building would cost about $178 million. Meanwhile, the US Department of Justice conducted an onsite review of OSH and found significant building defects. Before demolition could begin in June 2009, a community action group succeeded in having the campus accepted to the National Register of Historic Places on January 15, 2008.

The original section of the J Building, built in 1883, was incorporated into the new structure and renamed the Kirkbride U. The new hospital contains 620 beds and 870,000 square feet, divided into four units: Harbors, holding a facility identified as the ABC unit, for maximum security; Trails, a facility for medium security; Bridges, a facility for minimum security and transition to community care; and Springs, a facility for geriatric services. The first section, Harbors, opened in January 2011, and Trails opened in August 2011.

On February 17, 2012, the hospital offered a public tour of the third wing, housing the Springs and Bridges units, before it opened in March. The Springs unit houses civilly committed patients needing care for dementia, brain injury, or mental illness. The Bridges program houses patients transitioning out of the hospital. The final patients moved into the new, world-class, $280-million, 620-bed hospital complex on March 13, 2012. It is estimated that the Junction City facility, being built on land owned by the state prison system, will open in 2014. The new cremains memorial building will open in 2013.

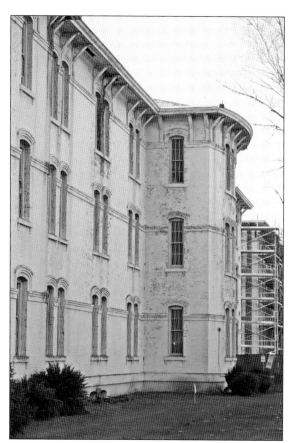

It took three weeks to demolish the south wing of the J Building, beginning in April 2009. Demolition of the north wing began on June 4, 2009, when the front portion was separated from the back portion. The new Kirkbride U was a compromise with the city of Salem's historic landmarks commission after the campus was added to the National Register of Historic Places. (Photograph by Laurie L. Burke.)

While history has lost the names of the artists who painted the old murals inside the hospital, new murals and patient artwork cover the walls inside the newly constructed wards. Supt. Greg Roberts arrived in September 2009 and instituted significant changes by slashing the number of internal committees, filling long-vacant administrative posts, streamlining how patient privileges were determined, and giving patients more say in their own treatment. (Photograph by Laurie L. Burke.)

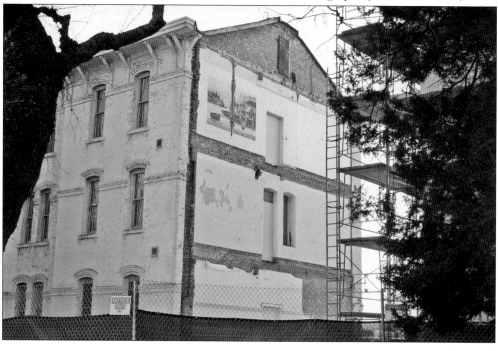

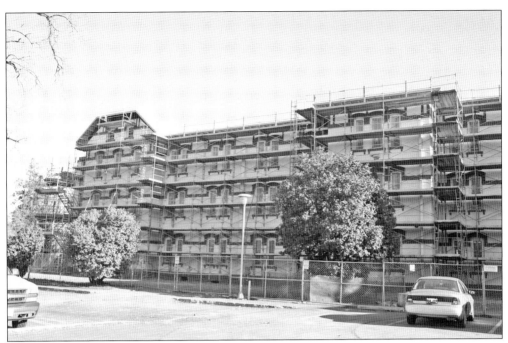

Construction could not begin until all the asbestos and lead paint was removed. Another stumbling block was funding an adequate level of staffing. It was estimated that OSH paid $25 million in overtime pay during the 2007–2009 biennium. (Photograph by Laurie L. Burke.)

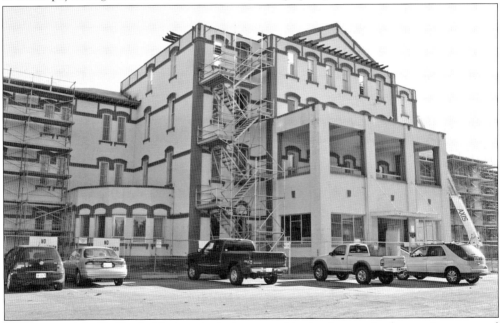

The center of the Kirkbride U, cleared of asbestos and lead paint, received extensive structural upgrades. First the roof was removed, and then new plumbing, electrical, and heating systems were installed to complete a top-to-bottom makeover. This section of the building was reinforced with steel rebar, thick layers of sprayed concrete, and new wooden beams. (Photograph by Laurie L. Burke.)

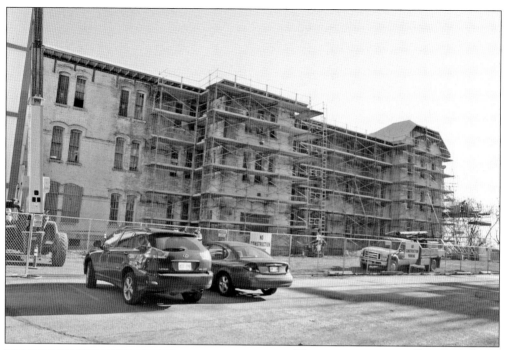

The new treatment mall system of care encourages patients to leave their rooms and enter an area that connects to a larger downtown mall so patients can access services and classes offered by the hospital. This centralized system of care offers opportunities to develop social and relationship skills, manage medication, avoid relapse, and enjoy a variety of therapeutic activities. (Photograph by Laurie L. Burke.)

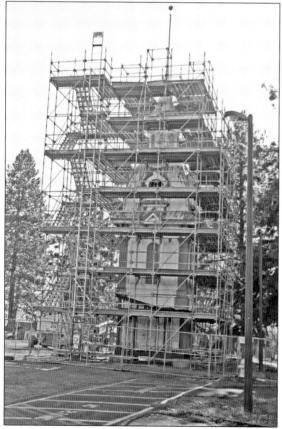

On December 5, 2009, the historic cupola was removed from the roof and lowered to the ground. Workers had to cut through wooden beams and attach cable to weight-bearing steel beams to lift the 31,000-pound, 124-foot dome from its perch. It was replaced on September 24, 2010, crowning the newly painted and restored 130-year-old structure. (Photograph by Laurie L. Burke.)

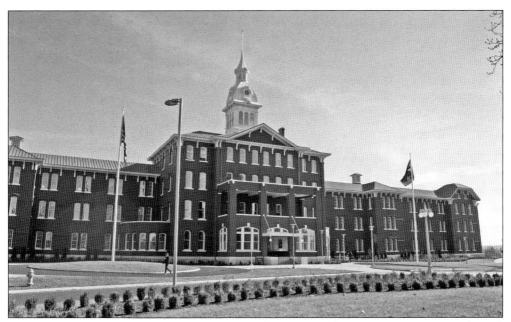

The first portion put into operation was the Admissions, Behavior, and Corrections (ABC) Building, also called Harbors. It opened on January 10, 2011, with 323 staff members and beds for 104 patients. There is no barbed wire or chain-link fencing, eliminating the prison-like feel around the three-story brick exterior. It took six weeks to apply the dark red paint to mimic the original brick appearance. (Courtesy of OSH.)

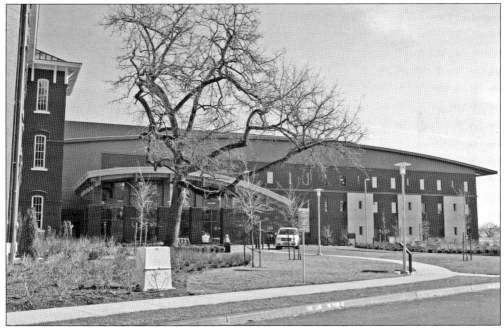

This is the new OSH entrance. The admissions unit has a 44-bed unit for new patients, the behavior section has 60 beds for violent patients, and the corrections unit has 20 beds for patients transferred from the penitentiary. The new wing includes 90,500 square feet of living space and 80,300 square feet for treatment. (Photograph by Laurie L. Burke.)

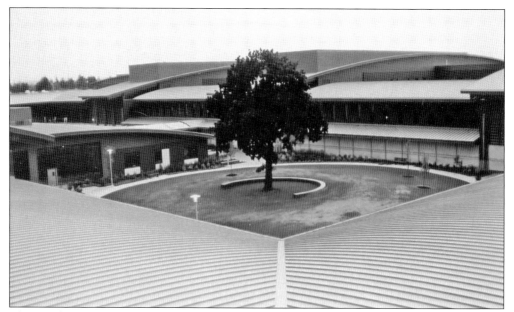

The new hospital has abundant natural light, with 22 courtyards and other open spaces. Short hallways radiate from nursing stations, where staff can see patients and monitor their activities. A gymnasium with a stage offers patients a place to exercise or watch programs. The new dining halls encourage patients and staff to eat together, just as they would in any hospital. (Courtesy of OSH.)

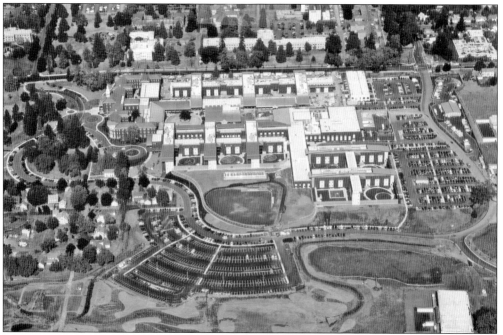

The treatment mall care model also dictates the design necessary to provide security for staff and patients. Four distinct patient groups are served: transitional and transition secure; psychosocial rehabilitation (PSR); admission behavioral corrections (ABC); and neuro-psych. (Courtesy of OSH.)

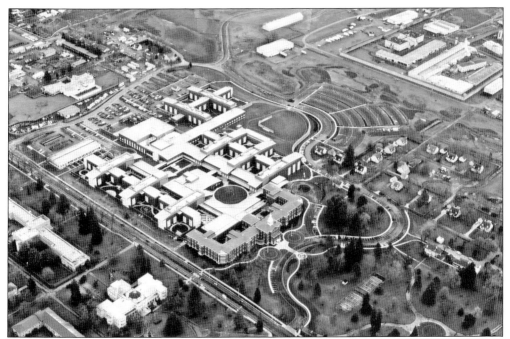

As of March 2012, OSH housed fewer than 600 patients. The last section was completed in that month. Patients were transferred into the last two treatment programs: Bridges, a transition program for patients preparing to leave the hospital; and Springs, which treats civilly committed patients receiving care for dementia, brain injury, or mental illness. (Courtesy of OSH.)

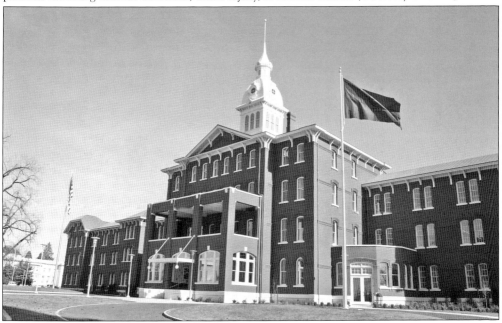

The Museum of Mental Health opened as a 501(c)(3) nonprofit organization on October 6, 2012, and occupies 2,500 square feet. The museum was able to salvage thousands of artifacts to display. It is hoped that the museum will educate the public and help it understand the many improvements made in caring for those with mental illnesses. (Photograph by Laurie L. Burke.)

Discover Thousands of Local History Books Featuring Millions of Vintage Images

Arcadia Publishing, the leading local history publisher in the United States, is committed to making history accessible and meaningful through publishing books that celebrate and preserve the heritage of America's people and places.

Find more books like this at
www.arcadiapublishing.com

Search for your hometown history, your old stomping grounds, and even your favorite sports team.

Consistent with our mission to preserve history on a local level, this book was printed in South Carolina on American-made paper and manufactured entirely in the United States. Products carrying the accredited Forest Stewardship Council (FSC) label are printed on 100 percent FSC-certified paper.